PAPER ANIMALS

PAPER ANIMALS

From butterflies to bears, grasshoppers to gazelles -
classic paper-folding projects from the world's diverse natural habitats

Robert J. Lang

THE
APPLE
PRESS

A QUINTET BOOK

Published by The Apple Press
6 Blundell Street
London N7 9BH

ISBN 1-85076-404-2

This book was designed and produced by
Quintet Publishing Limited
6 Blundell Street
London N7 9BH

Creative Director: Richard Dewing
Designer and Illustrator: Robert J. Lang
Project Editor: Damian Thompson
Editor: Lydia Darbyshire
Photographer: Jeremy Thomas

Typeset in the USA by Hunza Graphics, Berkeley, California
Manufactured in Singapore by Eray Scan Pte. Ltd.
Printed in Singapore by Star Standard Industries Pte. Ltd.

For Diane

Contents

Introduction

Paper is a common material—we are surrounded by it in our daily lives, and most of us discard hundreds of pounds of it every year. It is prosaic and mundane. Yet, hidden within even the most humble scrap of newsprint lie animals, birds, and flowers galore, all waiting for an appearance via just a few simple manipulations. The techniques by which paper may be transformed into marvelous creatures form the art of origami.

The word "origami" is Japanese, a compound of "ori" (**to fold**) and "kami" (**paper**). While origami originated in China, the birthplace of paper, it has been a part of Japanese culture for over a thousand years. Today, however, origami is an international hobby with artists and designers in almost every country. Through a stream of books, magazine articles, and holiday displays, the public has become increasingly aware of origami.

Active societies such as The Friends of the Origami Center of America and the British Origami Society (see **Sources**, p. 112) have been organized all over the world. Folders have used many novel and ingenious techniques to produce thousands of different models. There are action models—birds that flap their wings, frogs that jump, figures that tumble and rock, swimming dolphins, fiddling violinists, cuckoo clocks with pop-out birds. There are functional models—boxes, vases, bookmarks, wallets, rings, and cups and purely ornamental folds—stars, polyhedra, and patterned shapes. There are models designed specifically to be folded from dollar bills. Animal models, with their semblance of life, remain the most popular. In this book, I have chosen models representing animals from several different habitats from all over the world. You will create several of these habitats—an American swamp, a European alp, and an Australian forest, to name but a few. The diversity of ecosystems modeled here parallels the diversity of origami activity in the world today.

A large part of the appeal of origami is the challenge of creating elegant sculptures without violating the stringent principles of the craft. In fact, origami, though it yields a tangible result, is a kind of game. The strictest rules of this game allow only the folding of a single square of paper. A slight relaxation of the rules allows the use of rectangles, triangles, and hexagons; more liberal yet is the use of peculiar shapes or multiple sheets of paper. Cutting, gluing, and decorating are considered poor form but even these may on occasion have their place, depending on the purpose and strength of the effect. In this book, you will find the purest form of the art; each design is folded from a single uncut square of paper.

People often assume that the origami books or models with which they are acquainted mark the limits of the art of paper folding. The truth is that all the paper folding books ever published represent only a small fraction of the designs that have been created, and these in turn are only an intimation of what is yet possible. As you fold the models in this book, I encourage you to play with the models and try your own modifications. You could change the posture, the attitude, perhaps even the species of animal. As you become more practiced, you may find yourself inventing entirely new creations, and thereby make your own contribution to this fascinating art.

Paper

Many different types of paper can be used for origami. The choice depends on the type and size of the model to be folded, the finished appearance desired, and what paper is available. Basically, any paper that can hold a crease and not tear or crack when folded back and forth is suitable. Some models are designed to use paper with a different color on each side to achieve a color contrast in the finished model. In this book the drawings for such designs are toned accordingly.

Commercial origami paper comes in packages of pre-cut sheets, 3 to 10 inches (7.5 – 25 cm) square, usually white on one side and colored on the other. Some types have multi-colored patterns on one side, or a different color on each side. For larger sheets of two-tone paper, various gift wrapping papers can be cut to the size desired. An accurate paper cutter, the larger the better, or a knife and carpenter's square, are very useful for this.

Some origami models look best folded from paper that can be molded and can hold its shape. Paper-backed foil, such as gift wrap, works very well for this and is easy to use, although crease marks, once made, are indelible. Look for high-quality paper-backed foils; the color should not fade from light or rub off along creases and the foil should not crack when folded back and forth. As a general rule, the thinner foil-backed papers work best; the thinnest papers are usually found at artists' supply stores.

It is also possible to make your own foil-backed paper, by bonding tissue paper to both sides of ordinary household aluminum foil using spray adhesive (available in office and photographic supply stores). The resulting paper is very workable, and the combination of the translucent tissue and reflective foil gives a slightly mottled texture with the appearance of depth and a slight iridescence. Such a paper is suitable for insects and other creatures involving small, complex folds that require much shaping.

These are certainly not the only possibilities. Try experimenting with papers found in office, artist's, craft, and packaging supply stores to provide a variety for different requirements and appearances of origami models. As you become more adept at folding, you may try more unusual materials for folding: origami artists have folded designs from materials as diverse as sheet metal, soft clay, phyllo pastry, and flour tortillas!

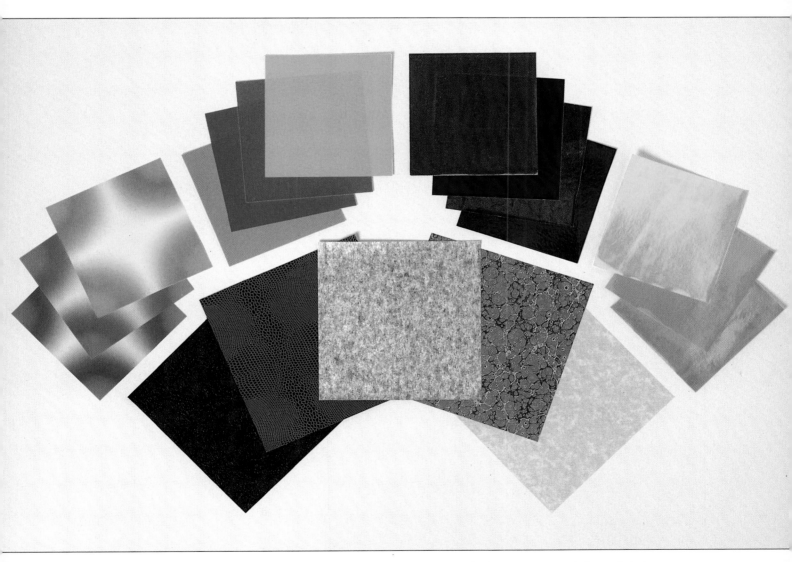

A selection of the different papers used by folders, including [top row, left to right]: graduated paper, traditional origami paper and foil-backed paper; [bottom row, left to right] textured paper, lizardskin, textured foil, printed paper and marble [elephantskin] paper.

◆ symbols and terms ◆

Before folding the models in this book, first study the explanation of the symbols and procedures in these 17 pages. Refer back to this section whenever necessary. The models range in complexity from fairly simple to intermediate in difficulty and are presented roughly in that order, although there is some variation within each group of models.

Origami folds are communicated through drawings showing the progression of the fold as well as verbal instructions. Each drawing shows two things: the result of the previous step, and what action is taken next. Before performing the operation immediately shown, look ahead to the next step, or next several steps, to see what the result will be.

Verbal instructions are provided for each step and should be used with the drawings. The terms "upper," "lower," "top," "bottom," "left," "right," "horizontal," and "vertical" refer to the dimensions of the page itself: thus "toward the top" means "toward the top of the page." The terms "front" and "near" refer to location or motion perpendicular to the page, that is, toward the folder; the terms "far," "behind," and "back" refer to location or motion away from the folder. The terms "in" and "inward" mean toward the middle of the model; the terms "out" and "outward" mean away from the middle. An edge can be a folded edge or a raw edge, which is is part of the original edge of the square. These terms are illustrated below.

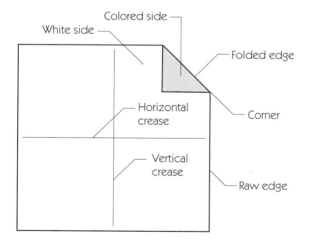

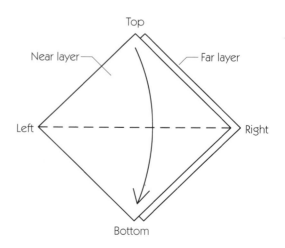

Most of the legs, wings, and other appendages of origami animals are made from flaps of paper. A simple flap has two sides: the spine, which is closed, and the open side, which consists of one or more edges. Some flaps have several layers on the open side; more complicated flaps can have several layers on each side.

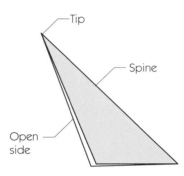

Origami diagrams are drawn as if the paper were opened slightly to display the ordering of multiple layers within the model. However, you should always fold the model so that all edges are made to line up as neatly as possible (unless otherwise instructed).

 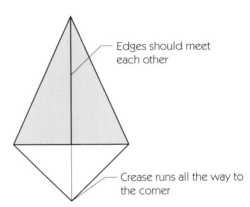

This is how the model will be drawn

This is how your paper should actually look

Fold accurately, making sharp creases. Origami is a geometrical art, and for this reason there is little tolerance for error in the folding process. Small inaccuracies at the beginning turn into large ones as the sequence progresses. The appeal of many models, however, can be enhanced by subtle shaping, rounding, and adjustment of the finished form.

Traditional origami paper is colored on one side and white on the other. All of the instructions in this book are drawn as if there were a colored side and a white side of the paper. Of course, you may fold the models from paper that is the same color on both sides, as are many of the models in the photographs.

**Several basic procedures are common to most origami designs.
These procedures, and the symbols used to indicate them,
are illustrated in the following pages.**

Valley Fold

When a flap or layer of paper is folded so that the crease forms a trough, that is
called a valley fold. Valley folds are the most common types of fold, and in this
book, wherever the word "fold" is used by itself to describe an action, it
means "valley-fold." A valley fold is indicated by a dashed line, and an arrow
with a symmetrical split head shows the motion of the paper. In this example,
the top of the paper is folded down to meet the bottom, making a valley fold.

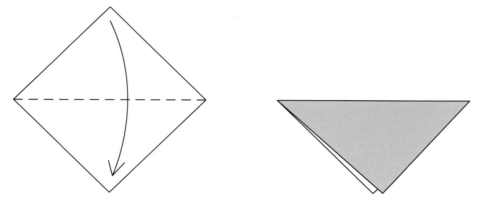

Most of the time, a valley fold forms automatically when you bring one point or
edge to another and flatten the paper. In the first example below, you bring
edge AB up to edge CD and when you flatten the paper, the crease
automatically forms in the right place.

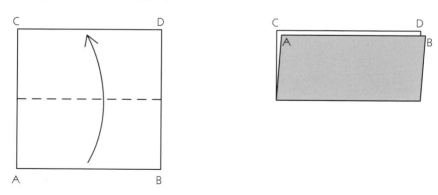

It is usually easier to fold a point or edge from the bottom upward, as shown
above. This gives you a good view of the crease as it is being formed so that
you can make sure that it forms in the right place. If the drawing shows a point
being folded downward, you can rotate the paper so that the direction of the
fold is upward. Be sure you return the paper to its original orientation,
however.

An exception to this rule arises when you are folding so that the crease goes through a particular point. In this case, you might find it easier to make the crease go through the reference points by folding the paper toward you so that you can see the reference creases.

To make a crease that accurately connects two points, make a small pinch mark at each of the two points, then gradually flatten the paper between them, making the crease sharp a little at a time, until the paper is completely flat.

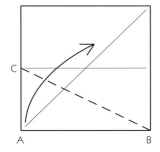

To make a crease that runs from C to B...

first, make a small pinch at point C...

then make a small pinch at point B...

finally, flatten the crease between points B and C, a little at a time, until it is sharp.

Mountain Fold

When a flap or layer of paper is folded away from you so that the crease forms a peak, that is called a mountain fold. A mountain fold is indicated by a dot-dot-dash line and an arrow with a one-sided hollow head showing the motion of the paper. In general, if the arrow has a split head, the paper starts out moving toward you; if the head is hollow, the paper moves away from you.

Sometimes a mountain fold is more easily accomplished by turning the paper over to perform it. For example, you can sometimes do a mountain fold by turning the paper over, doing a valley fold, and then returning it to its original position. You should always be sure that you return the paper to the orientation shown in the next drawing before proceeding.

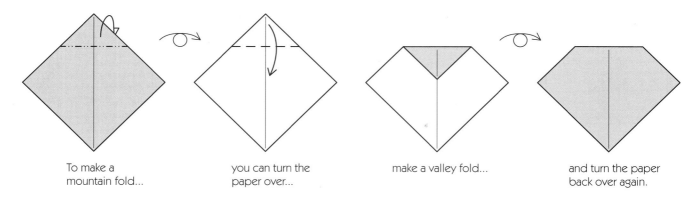

To make a
mountain fold...

you can turn the
paper over...

make a valley fold...

and turn the paper
back over again.

However, a mountain fold is also often used to tuck a flap inside a pocket, in which case turning the paper over is not necessarily useful.

This method won't work if you are
tucking the flap in front of another.

X-ray Line

A dotted line is used to indicate a fold or an edge that is hidden, and in this respect is similar to the cut-away view. Typically, an x-ray line will be used to indicate the continuation of a fold behind a flap, while the cut-away view is used to show more complicated structures. This example also shows that the mountain fold line may be extended past the edge of the paper if not enough of it is showing otherwise.

Unfold

Sometimes you will need to undo a fold you have made previously. This procedure is indicated by a hollow open arrowhead. You will often do this in the beginning steps of a model, when you are establishing some guide creases for reference.

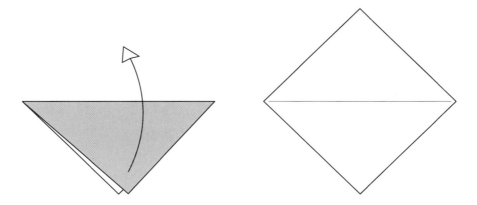

The same symbol is used to indicate that you should pull some paper out of a pocket or unwrap a layer of paper, as in the examples shown here.

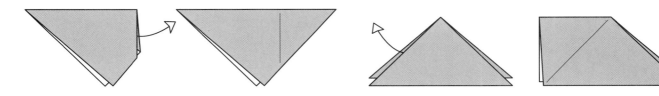

Fold and Unfold

When you are making guide creases, you fold the paper in a particular way and then unfold it, which is normally drawn in two separate steps (one to fold the paper, one to unfold the paper). We will often combine the two steps into one, by using an arrow with a valley fold arrowhead on one end and an unfold arrowhead on the other. This arrow means to fold and unfold.

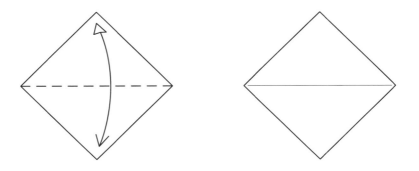

After you have unfolded a step, the creases that remain are indicated by thinner lines. Where a crease meets an edge, there will be a small gap, to emphasize its presence and further differentiate it from an edge. Creases are sometimes used as references, and sometimes used to establish the location of more difficult folds such as reverse folds and petal folds.

Quite often, when you fold and unfold it will be for the purpose of making a reference mark. The appearance of your final model will be better if you make your pinch marks small and unobtrusive. (It will also be easier to follow the diagrams if your paper isn't covered by extraneous creases.) If you need only the point where one crease crosses another (or hits an edge) for reference, then in the diagrams, the crease will be shown as a dotted line along its length and as a valley fold only where you need to make it sharp. The example shown below is a standard technique for dividing a square into thirds; the point where the crease crosses the diagonal divides the paper into thirds.

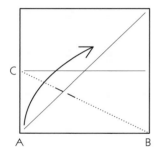

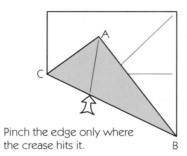

Pinch the edge only where the crease hits it.

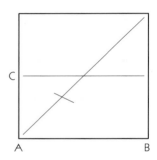

Watch This Spot

In this book, important reference points are marked with letters, which have a reference in the verbal instructions. Often, the position of a lettered flap in one step can clarify any ambiguity in the previous step.

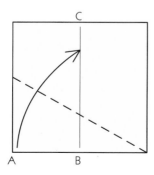

Rotate the Paper

A circle with two arrows indicates to rotate the model in the plane of the page. The direction of rotation is indicated by the direction of the arrows; the amount of rotation is given by the fraction in the center of the circle as a fraction of a complete revolution. For example, in the first figure below, you should rotate the model one-quarter turn clockwise.

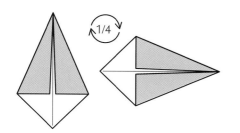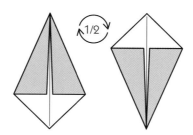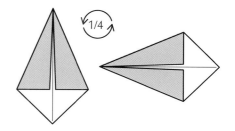

Fold Over and Over

An arrow that touches down more than once indicates to valley-fold once, and then valley-fold again (and again, if necessary, for as many times as the arrow touches down).

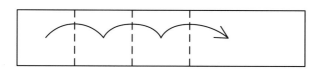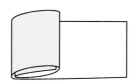

Turn the Paper Over

An arrow that makes a loop means you should turn the entire model over. If the arrow runs horizontally, the paper should be turned over from side to side. If it runs vertically, the paper should be turned over from top to bottom.

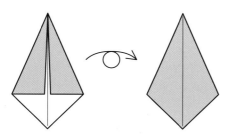

Cut-away and Partial Views

A solid circle is used to give a view of hidden layers of paper, drawn as if the near layers of paper were cut away to expose the inner layers. Similarly, sometimes only a portion of the model will be shown in a close-up view, in which case no edge will be drawn where the rest of the model should be.

Repeat Steps

In many folds, an entire sequence of folds will be repeated on a different part of the model—the most common occurrence is when you do the same thing on both sides of the paper (folding the left and right side of an animal, for example). When this is to be done, the range of steps will be called out in the verbal directions. In addition, a boxed list of the steps to be repeated will appear with a leader pointing to the flap or flaps affected. An example is shown below.

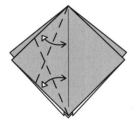 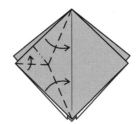 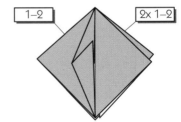 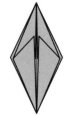

1 Fold and unfold.

2 Fold a rabbit ear (see page 22) from the flap.

3 Repeat steps 1–2 on the left side and on both flaps on the right. (You should turn the model over to do the two rear flaps.)

4 The result looks like this on both sides.

When the instructions say, for example, "repeat steps 1–3 behind," you should turn the paper over and perform steps 1–3 on what is now the mirror image of the drawings. When you are done, you may or may not be told to turn the paper back to its original orientation. You should always be sure that the paper is in the proper orientation before beginning the next step.

Push Here

A small, hollow arrow with a split tail indicates "push here." Usually, that means that rather than being folded toward or away from you, the paper is pushed in symmetrically, or even inverted. For more examples of this, see Reverse Folds (below) and the Squash Fold (page 23).

 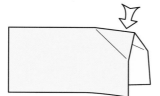 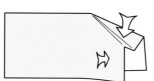 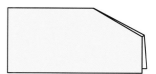

Reverse Folds

Several other combinations of mountain and valley folds occur over and over in origami; they are so common that we give them special names. One of these folds is the "reverse fold," which is so named because you turn a portion of the paper inside out. The model shown below is one upon which you can practice reverse folds.

 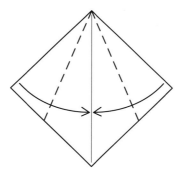 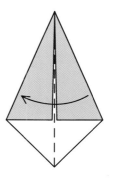 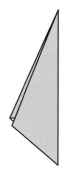

Here is a shape you can use to practice making reverse folds. Fold the paper in half along the diagonal and unfold.

Fold the upper sides in to lie along the crease you just made.

Fold the model in half along the vertical crease.

Now we will use this shape to illustrate reverse folds.

Inside Reverse Fold

The inside reverse fold is a way of changing the direction of a flap that is more permanent than simply folding it over would be. An inside reverse fold is indicated by a mountain fold line on the near layer of paper and a valley fold line on the far layer if it is visible. There is also a push arrow pointing to the spine of the fold. Inside reverse folds are usually referred to simply as "reverse folds" in this book.

To make an inside reverse fold, first fold the flap along the indicated fold line, front and back, and unfold; this is to weaken the paper to make the reverse fold easier. When you are just starting out, you should do this two or three times in each direction to make sure that the paper is thoroughly weakened along the fold line. To make the actual fold, spread the near and far layers of paper and push the spine of the moving flap down between them. The flap turns inside-out in the process (hence the name "reverse fold"). Flatten the paper. Be sure that all folding occurs on the existing creases and that you don't add any new ones after the pre-creasing! As you become more experienced in folding origami, you will develop the ability to make reverse folds without pre-creasing, but if you are a beginner, it will always be easier if you begin by pre-creasing the paper.

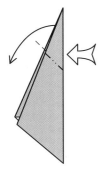

This is how an inside reverse fold is drawn.

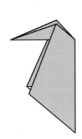

The result looks like this. Note the order of the layers.

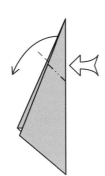

Here is an easy way of making an inside reverse fold.

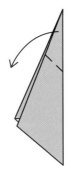

Begin an inside reverse fold by valley-folding the point down at the appropriate angle.

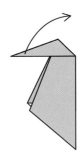

Note that the point is in exactly the same position as it will be when the reverse fold is finished. Unfold.

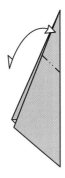

Mountain-fold the point behind on the same crease. The goal here is to weaken the paper so that it folds as easily in one direction as the other.

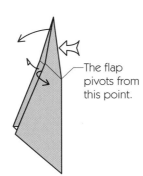

The flap pivots from this point.

Open the edges of the flap apart from each other and push on the spine, so that the top of the flap starts to pivot and flatten.

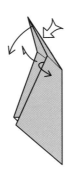

In progress. Keep pushing on the spine until the flap goes down between the layers and turns inside-out.

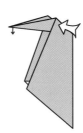

In progress. When the crease up the spine of the flap has reversed its direction, the model will flatten easily.

Completed inside reverse fold.

Outside Reverse Fold

The outside reverse fold is also a way of changing the direction of a flap. While the inside reverse fold turns a flap toward its open edges, the outside reverse fold turns it in the opposite direction. An outside reverse fold is indicated by a valley fold on the near layer of paper (and a mountain fold on the far layer, if it is visible) and arrows showing the direction of motion of the paper.

To make an outside reverse fold, first fold and unfold the flap along the intended crease line to weaken the paper. Then, spread the layers of the moving flap and wrap them around the rest of the model. Flatten the paper . As with the inside reverse fold, until you become more experienced, you should always pre-crease the fold.

This is how an outside reverse fold is drawn.

This is what the completed fold looks like. Note the order of the layers.

Here is an easy way to make an outside reverse fold.

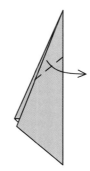

As with the inside reverse fold, begin the outside reverse fold by valley-folding the point over at the angle at which you wish the reverse fold to be made.

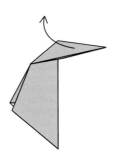

Unfold. Repeat in the other direction until the paper folds easily in either direction.

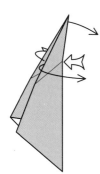

Spread the outside edges apart and push in the spine where the crease hits it. You will have to spread the edges farther for an outside reverse fold than for an inside reverse fold.

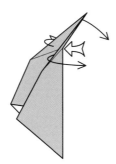

As the tip progresses, it will "pop" inside-out.

Once the crease that runs along the spine has changed its direction, it will flatten easily.

Complete outside reverse fold.

Rabbit Ear

The rabbit ear is a way of narrowing a flap and changing its direction. It is indicated by three valley folds that meet at a point and a fourth mountain fold emanating from that point. Nearly always, the flap is a triangle and the three valley folds bisect the angles of the triangle. The way to start, therefore, is to crease each of the angle bisectors. Then, bring two sides of the flap together and pinch it in half. Swing the flap down to the side and flatten the paper.

A rabbit ear that uses the same valley folds can go in two different directions. In a model's directions, arrows and the location of the mountain fold will show which way it goes.

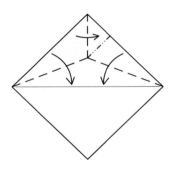

This is how a rabbit ear is diagrammed. Three valley folds and a mountain fold that meet at a point make a rabbit ear.

This is how a rabbit ear looks when it is done.

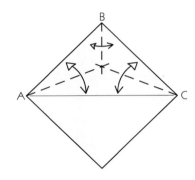

This is how to fold a rabbit ear. The valley folds in a rabbit ear usually connect the corners of a triangle to a central point (in this example, the triangle's three corners are points A, B, and C). You should start by folding edge AB to AC; BA to BC; and CA to CB. The three creases you make should all meet at the same point.

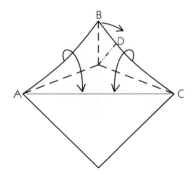

Bring edges AB and BC together along line AC; the extra paper goes into a flap that ends in point B. Swing point B toward the side that the mountain fold was on (the right, in this example).

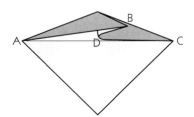

Flatten the model. The crease that hits point D forms naturally in the right place.

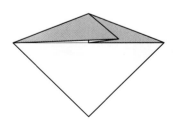

The finished rabbit ear.

Squash and Petal Folds

Squash and petal folds are two types of folds that are somewhat more complicated than inside and outside reverse folds. They are used to create new points and edges in a model.

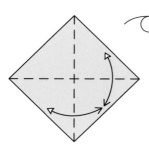
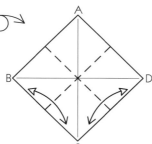
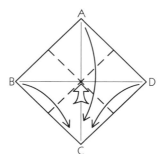
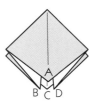

Here is a shape you can practice squash and petal folds upon. Fold the square in half along the diagonals and turn over.

Fold edge AB down to CD and unfold. Fold edge AD down to BC and unfold.

Bring all four corners together at the bottom while pushing in the middle.

Flatten.

This shape is called the Preliminary Fold.

Squash Fold

The squash fold is a way of converting one folded edge into two. It is indicated by a valley and mountain fold line and a push arrow pointing to the edge to be squashed. To make a squash fold, spread the open layers of the edge to be squashed and flatten them so that the edge ends up on top of the fold line at the base of the flap, as point A does in the example.

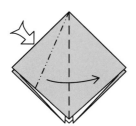
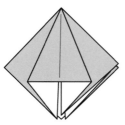
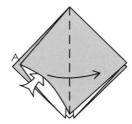
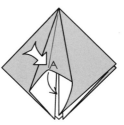
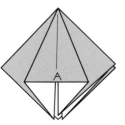

This is how a squash fold is drawn.

The result looks like this.

Here is how to make a squash fold. Put your finger inside the pocket and spread its edges apart.

Flatten out the flap so that point A hits the folded edges underneath. The remaining folds form automatically.

Complete squash fold.

Petal Fold

The petal fold is a means of simultaneously narrowing and lengthening a point. It is indicated by two mountain folds and a valley fold that form a triangle, with a push arrow on each side of the petal fold. The mountain folds are nearly always angle bisectors, and when you pre-crease (as shown in the example below), you should make the creases that become the mountain folds first. Then, make a valley fold to form a crease that connects the mountain folds where they hit the outer edges. Next, lift up the point along the valley fold just made, and simultaneously push in the edges on the sides. Watch the two points marked A and C in the example; they end up meeting in the middle when the petal fold is completed.

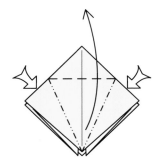

This is how a petal fold is drawn.

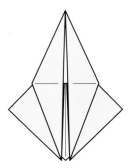

The result looks like this.

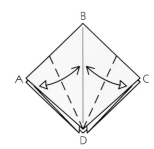

Here is how to make a petal fold. Make a Preliminary Fold (see page 23) to practice on. Fold in edges AD and CD to line BD and unfold.

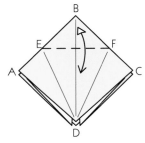

Now fold down corner B along a crease that runs between points E and F.

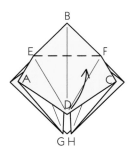

Lift corner D upward with one hand while holding points G and H down with the other. Corners A and C will move toward each other.

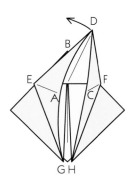

As you flatten the point, creases ED and FD change from valley to mountain folds; you might need to change the creases' direction directly. No new creases are added, however.

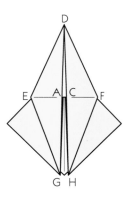

Completed petal fold.

Petal-folding an Edge

It is also possible to create a new point from the middle of an edge with a petal fold, as shown here. To make this kind of petal fold, first crease the angle bisectors at the bottom of the model. Then fold the edge up along a valley fold that connects the top of the first two creases. Push in the sides and flatten the paper ; two new valley folds form that converge at a single point in the middle of the edge. Watch the points marked A and B; as the petal fold is made, they move in from the sides and meet in the center of the model.

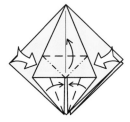

This is how a petal fold is drawn when it is applied to an edge.

The result looks like this.

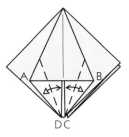

Here is an easy way of petal-folding an edge. First fold in edges AD and BC to the center line and unfold.

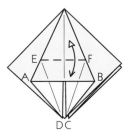

Then fold down the top part of the model so that the crease connects points E and F; unfold.

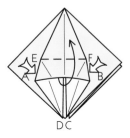

Now hold down points D and C and lift up the middle of edge AB; corners A and B will move toward each other.

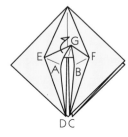

Flatten the model. The two creases that create point G from an edge fall naturally into place, but you should adjust them to make the point sharp and even before you make the creases sharp.

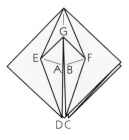

Completed petal fold.

Crimps and Pleats

When a flap with several layers is folded in a short zig-zag, there is more than one way the layers can be folded; the entire flap can be folded back and forth or it can be folded inside itself and back out. To distinguish these cases, one or more zig-zag lines is drawn next to the model as if it were a side view of the edges.

A pleat occurs when the entire flap is folded back and forth, as in the example below. Pleats are usually very easy to do, and the only thing that you have to be careful about is whether the valley fold (which is the fold you should make first) is on the right or the left of the mountain fold. A pleat may be made through a single layer of paper or multiple layers of paper.

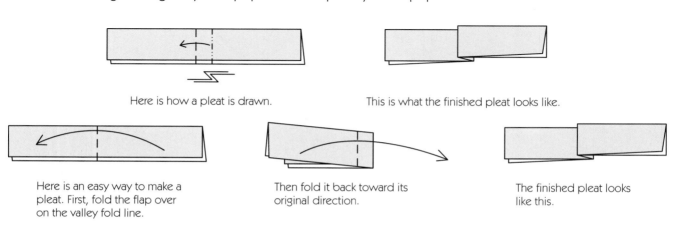

Here is how a pleat is drawn.

This is what the finished pleat looks like.

Here is an easy way to make a pleat. First, fold the flap over on the valley fold line.

Then fold it back toward its original direction.

The finished pleat looks like this.

A crimp, somewhat harder than a pleat, occurs when the two edges of a flap both go inside or outside the flap. A crimp can often be made as a pair of reverse folds, as shown below.

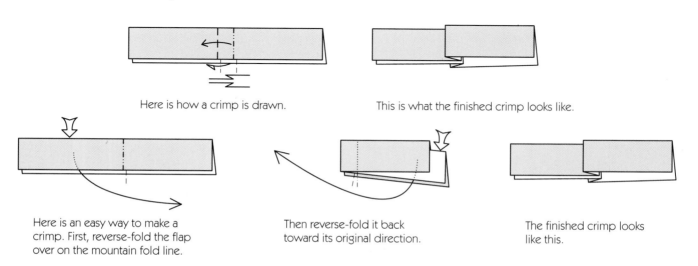

Here is how a crimp is drawn.

This is what the finished crimp looks like.

Here is an easy way to make a crimp. First, reverse-fold the flap over on the mountain fold line.

Then reverse-fold it back toward its original direction.

The finished crimp looks like this.

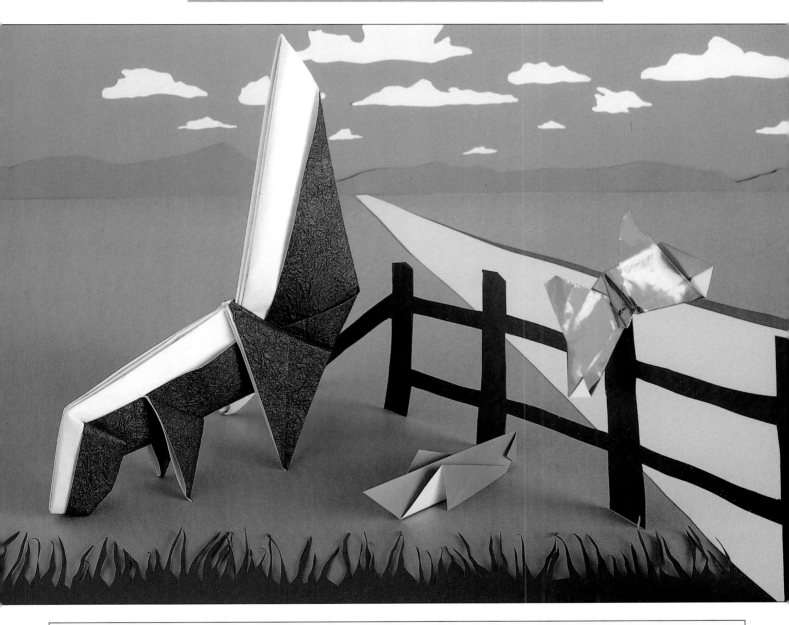

For this project, you will fold the following models:

Name	Page	Rating	Paper requirements
Grasshopper	28	Easy	4 in (10 cm) square of crisp, brightly colored paper
Butterfly	30	Easy	6 in (15 cm) square of thin, crisp paper
Skunk	32	High Intermediate	18 in (45 cm) square of thin paper, black on one side

◆ grasshopper ◆

designed by Gay Merrill Gross

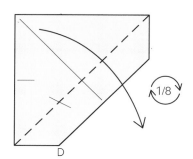

1 Begin with the white side up. Crease the diagonals and turn the paper over.

2 Fold the bottom right corner up to the top. Make a small pinch at the right edge and unfold.

3 Make a crease that runs from A to B, making it sharp only where it crosses the diagonal crease.

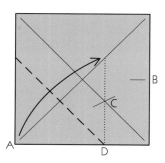

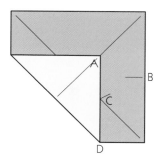

4 Fold up corner A to lie on the diagonal crease so that edge AD runs through point C.

5 Turn over the paper.

6 Fold down the top left corner. Rotate the paper 1/8 turn.

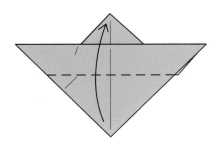

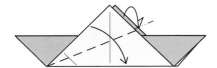

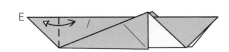

7 Fold the bottom corner up to match the top corner.

8 Fold down the near flap so that its edge lies along the bottom edge of the model. Repeat behind.

9 Fold the left point over and unfold.

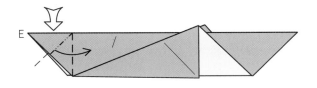

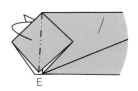

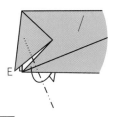

10 Squash-fold point E.

11 Fold one layer behind.

12 There are two corners trapped under point E. Mountain-fold each of them to the inside.

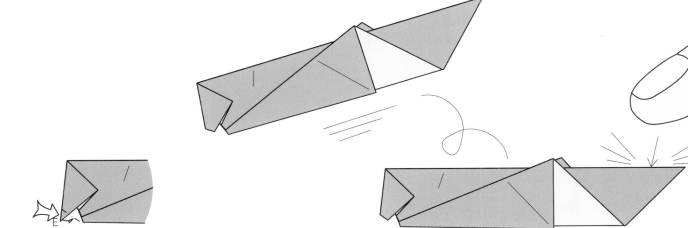

13 Reverse-fold the tip of the head.

Finished Grasshopper. Tap sharply on his tail to make him jump.

◆ butterfly ◆

designed by Gay Merrill Gross

1 Begin with the white side up. Fold the paper in half along one diagonal and unfold.

2 Fold the bottom point up to the top point; pinch in the middle and unfold.

3 Fold the bottom point up to the crease you just made; pinch in the middle and unfold.

4 Repeat step 3 two more times.

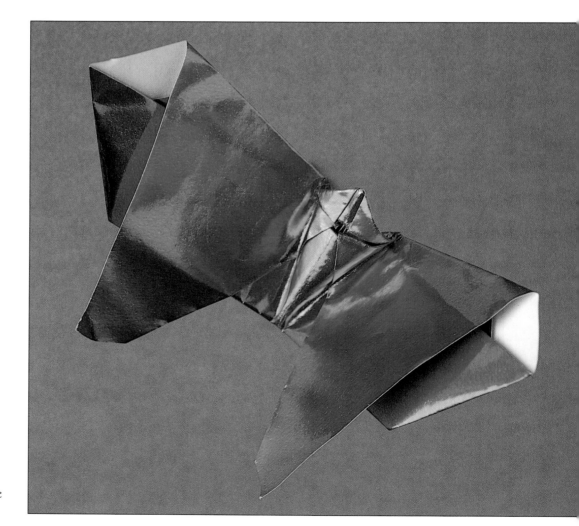

5 Now fold the top point down to the last crease and leave it in place.

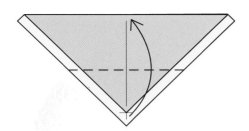

6 Fold both layers together so the bottom point comes up to touch the top edge in the middle.

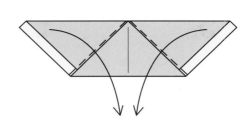

7 Fold the left and right corners down so that their edges meet in the middle.

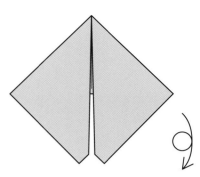

8 Turn the model over from top to bottom.

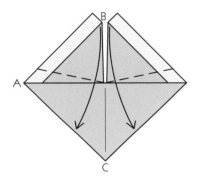

9 Fold down corner B to lie on edge AC. Repeat on the right.

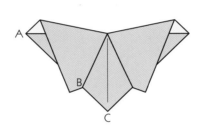

10 Turn over the paper.

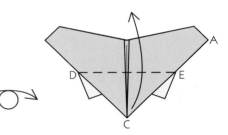

11 Fold corner C up. Note that the crease runs between points D and E, each of which lies at the intersection of two edges.

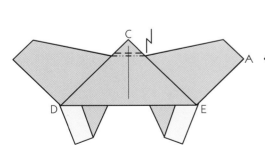

12 Pleat the top corner. Note that the bottom fold is the mountain fold.

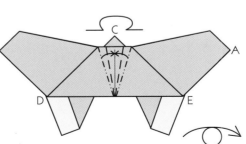

13 Pleat the body on each side, leaving the valley folds slightly rounded. Curling the body around a pencil helps. Turn the model over.

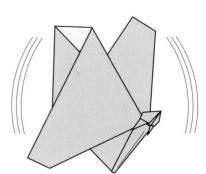

Finished Butterfly.

◆ skunk ◆

designed by Aaron Einbond

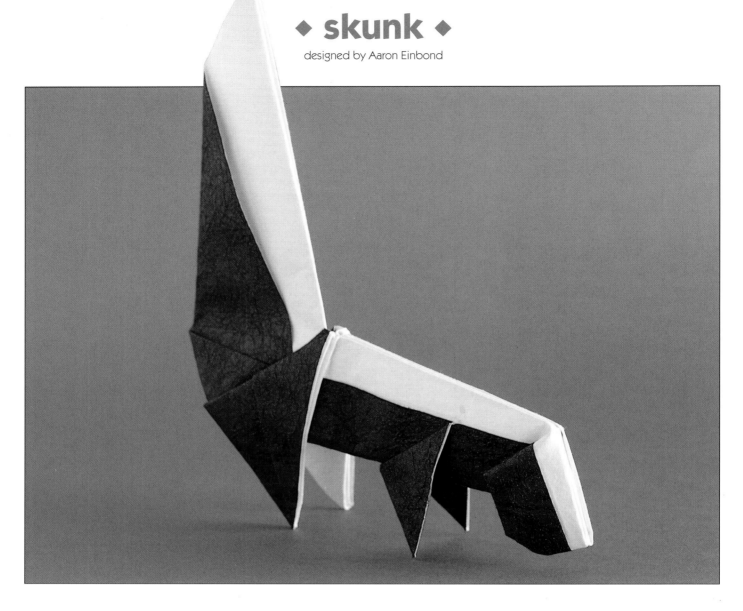

1 Begin with the white side up. Fold and unfold both diagonals.

2 Fold and unfold vertically and horizontally. Turn the paper over.

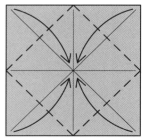

3 Fold the corners to the center.

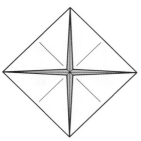

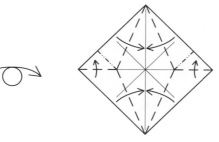

4 Turn over the model.

5 Fold a rabbit ear from the right and left corners. Be careful with the loose layers behind.

6 Pull out the loose paper from behind.

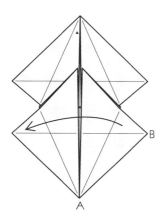
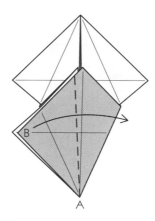
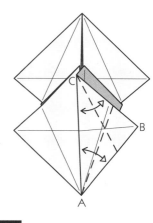

7 Fold flap B to the left.

8 Fold flap B back to the right. Note that the crease doesn't hit the corner at the top.

9 Fold edge AB to edge AC, crease, and unfold. (Note that this fold is not the same as the one that's already there.) Fold edge BC to edge AC, crease, and unfold.

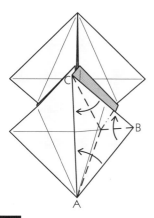
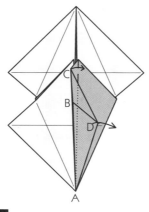
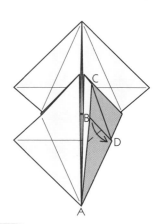

10 Use the crease you just made to make a rabbit ear of corner B.

11 Slide corner D over to the right (the crease already exists). Flatten the model.

12 Fold corner B down to corner D.

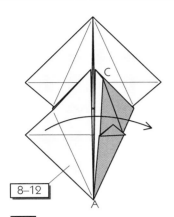

13 Repeat steps 8–12 on the left flap.

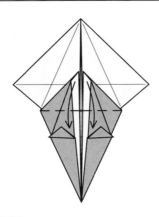

14 Fold two corners as far downward as possible.

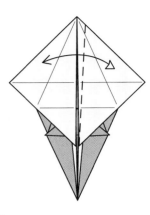

15 Fold the right corner to the left at the same angle as you did in step 8, crease, and unfold.

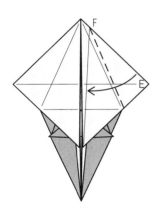

16 Fold edge EF in to lie along the crease you just made.

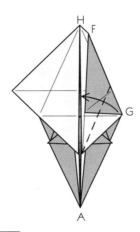

17 Fold corner G in to lie along the center line (line AH).

18 Repeat steps 15–17 on the left.

19 Fold the two points back up.

20 Fold each point to the outside. Note that both points wind up below corners I and J.

21 Turn the model over from top to bottom.

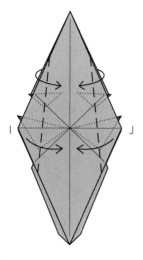

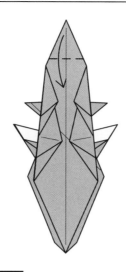

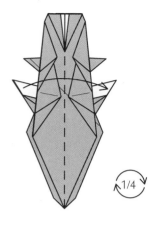

22 Fold the left and right edges in. At the top, you are folding a double layer of paper.

23 Fold down the top point.

24 Fold the model in half. Rotate 1/4 turn clockwise.

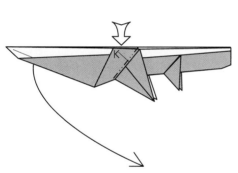

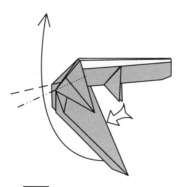

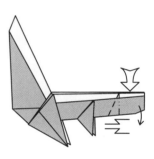

25 Reverse-fold the tail down. Note that corner K (and the corresponding corner behind) goes inside the reverse fold.

26 Reverse-fold the tail back up.

27 Crimp the head downward.

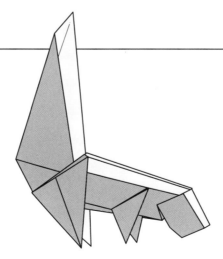

Finished Skunk.

◆ Swiss alp ◆

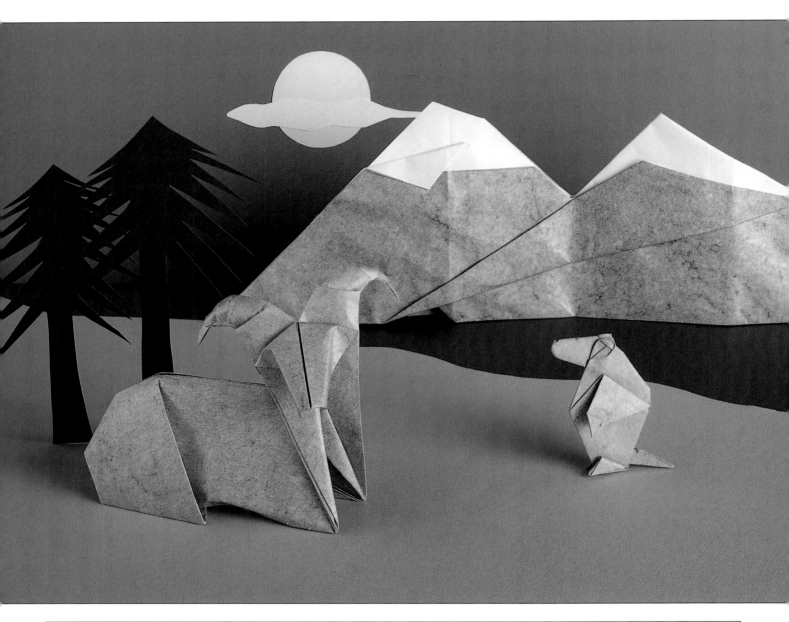

For this project, you will fold the following models:

Name	Page	Rating	Paper requirements
Mountain Range	37	Easy	24 in (60 cm) square of brown paper, white on one side
Marmot	39	Low Intermediate	6 in (15 cm) square of brown paper
Ibex	42	Low Intermediate	12 in (30 cm) square of tan paper, white on one side

◆ mountain range ◆

designed by Gloria Farison

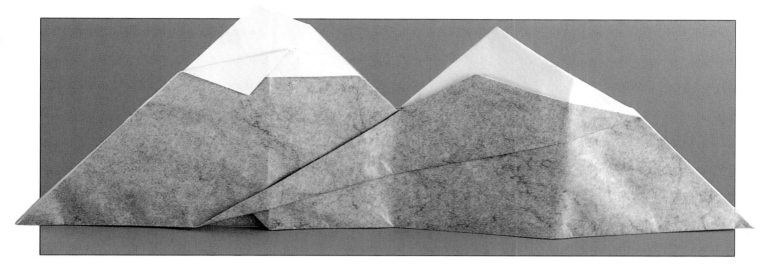

1 Begin with the white side up. Fold and unfold the paper vertically and along the diagonals.

2 Fold the two bottom corners up to meet in the middle of the paper.

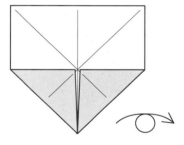

3 Turn the model over.

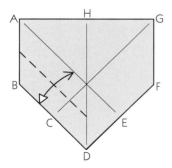

4 Fold edge BD up to lie along crease AE, making the crease sharp only from side AB to where it hits crease HD. Unfold.

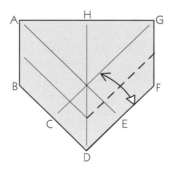

5 Repeat on the right with edge DF.

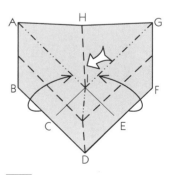

6 Bring edges BD and DF up and toward each other. At the same time, push down on crease HI. Look ahead to step 7 to see the shape you are trying to make.

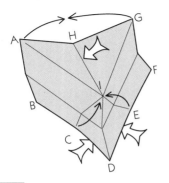

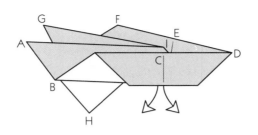

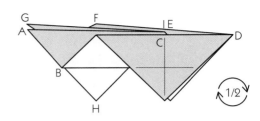

7 Bring C and E to I and bring corners A and G together.

8 Flatten completely and pull out the two loose corners from the bottom.

9 Rotate the model 1/2 turn.

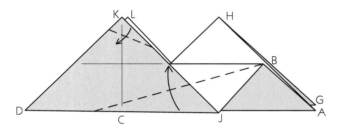

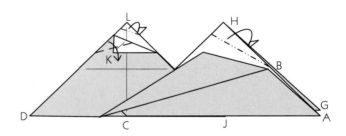

10 Fold down a portion of corner K (the exact amount isn't critical). Fold part of edge DJ upward so that the edge touches the saddle between the two peaks.

11 Fold corners L and H behind asymmetrically. Fold a portion of the edge down over corner K.

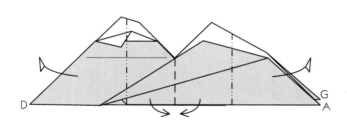

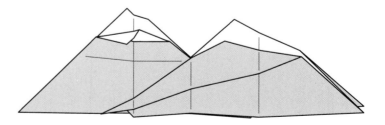

12 If you slightly pleat the model in a zig-zag as shown, the range will stand by itself. In addition, you can make more than one and tuck corners A and G into the pockets in corner D to make a longer mountain range.

Finished Mountain Range.

◆ **marmot** ◆

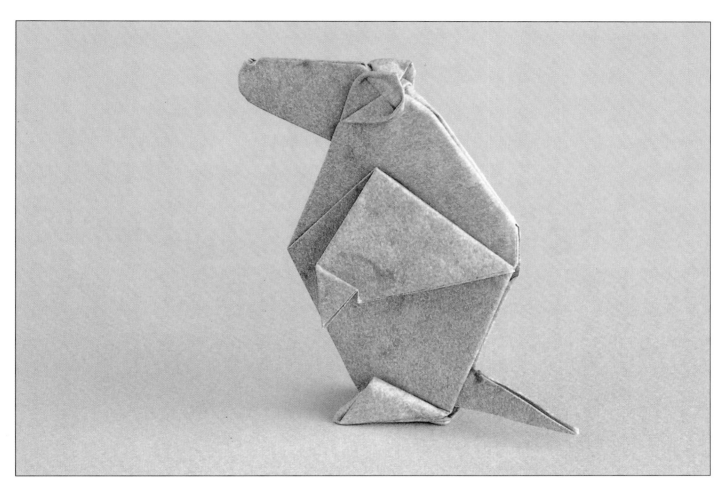

1 Begin with the white side up. Fold the paper in half along the diagonals and unfold.

2 Fold in each of the four edges to lie along the center line and unfold.

3 Bring all four edges to the center line at once.

4 Bring corners B and D upward and flatten the model.

5 Fold point A down to the point where two creases hit the raw edges (the crease runs just under points B and D). Unfold.

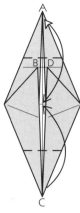

6 Fold points A and C to meet each other in the middle of the model; unfold point A.

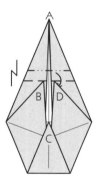

7 Pleat flap A downward behind flaps B and D, using the existing creases.

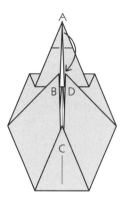

8 Fold down point A to meet corners B and D.

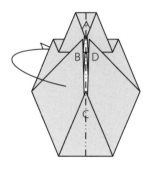

9 Mountain-fold the model in half.

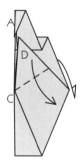

10 Fold corner D down in front. Repeat behind with corner B. There is no reference point for this crease.

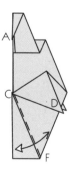

11 Fold the bottom along edge CF and unfold.

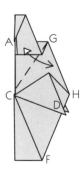

12 Fold the top down so that edge AG lies along edge GH; crease firmly and unfold.

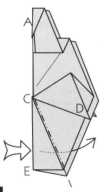

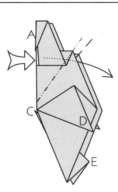

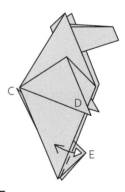

13 Reverse-fold edge CE to the right by pushing it between the layers of the body.

14 Reverse-fold the upper part of the model by pushing on edge CA so that it turns inside-out and goes between the layers of the body.

15 Fold and unfold.

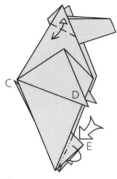

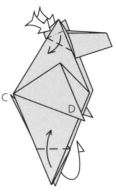

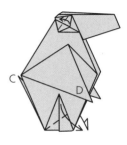

16 Reverse-fold corner E. Fold the ear down and unfold. Repeat behind on the other ear.

17 Squash-fold the ears. Fold one foot upward as far as possible on each side.

18 Valley-fold the feet down and to the right. Open up the ear by lifting the flap and rounding its edges. Repeat behind.

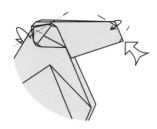

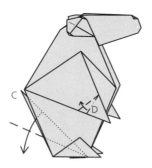

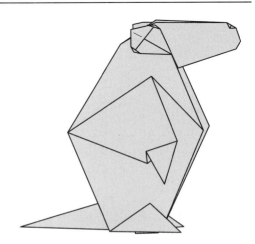

19 Enlarged view of head. Mountain-fold the corners behind the ears. Reverse-fold the bottom of the nose. Valley-fold one of the top corners of the nose; repeat behind.

20 Valley-fold corner C down from inside the body. Pleat the paw (point D). Repeat behind.

Finished Marmot.

◆ ibex ◆

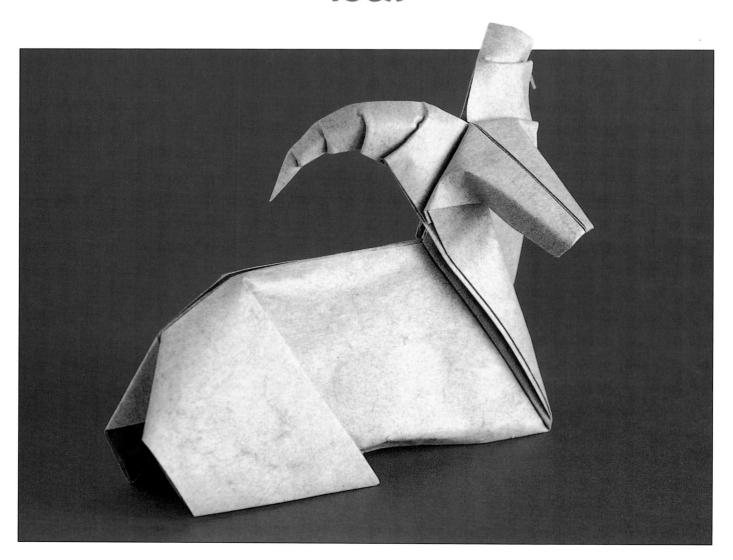

1 Begin with the white side up. Mountain-fold the top half of the paper behind.

2 Fold one edge up to the top edge in front. Repeat behind.

3 Fold the lower right corner up to lie along the top edge. Repeat behind.

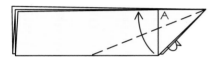
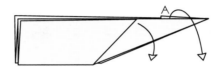
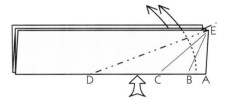

4 Fold the new lower right corner up to lie along the top edge—be careful that flap A stays put. Repeat behind.

5 Unfold to the beginning of step 3. Repeat behind.

6 Reverse-fold corner A upward along line DE (the crease you just made). Repeat behind.

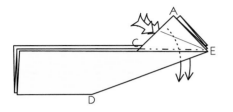
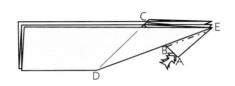
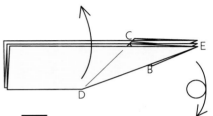

7 Reverse-fold corner A downward along line CE. Repeat behind.

8 Reverse-fold corner A upward along line BE. Repeat behind.

9 Fold corner D upward and turn the model over from top to bottom.

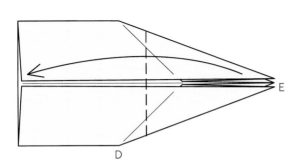
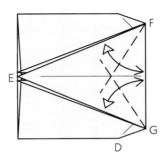
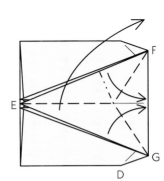

10 Fold point E over to the left edge.

11 Fold edge EG to edge FG, crease, and unfold. Repeat with edge EF.

12 Using the creases you just made, fold a rabbit ear from point E and swing the point upward.

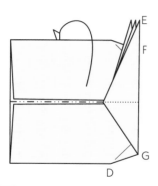

13 Mountain-fold the upper edge behind.

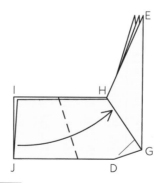

14 Fold edge IJ up to lie along edge HG; point J will wind up about halfway between H and G.

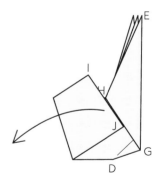

15 Unfold.

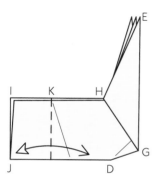

16 Fold the left side of the model to the right so that the crease runs through point K (where the last crease hit the top edge) and so point J stays on edge JD. Unfold.

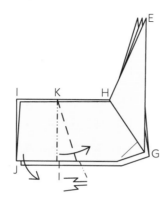

17 Crimp the left side of the model downward, using the creases you just made (some will need to be changed from valley folds to mountain folds and vice-versa).

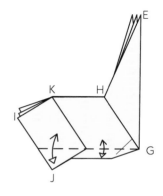

18 Fold and unfold through the near layers along a horizontal crease that runs through point G. Repeat behind.

19 Mountain-fold corner J inside along the crease you just made. Repeat behind.

20 Mountain-fold the bottom edge inside. Repeat behind.

21 Reverse-fold corner I, tucking the loose corners in as well.

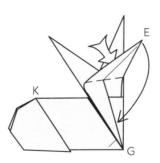

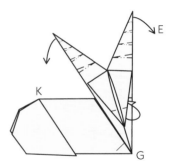

22 Fold two of the layers along edge EG to the left to lie along HG; one of the points at E comes over to the left, while the middle point opens out and begins to swing downward.

23 Squash-fold point E downward.

24 Mountain-fold the tip of the nose underneath. Pleat the horns. Note that in in the horn pleats, the lower fold of each pair is the mountain fold while the upper fold is the valley fold.

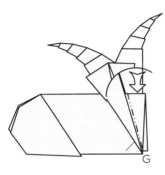

25 Reverse-fold the thick edge that lies behind the head (which is shown cut-away here).

26 Narrow the horns with mountain folds, folding through all layers. Narrow the head by mountain-folding its sides underneath. Round and shape the body.

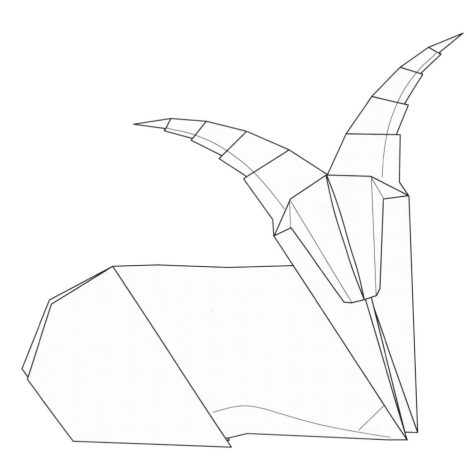

Finished Ibex.

◆ Louisiana bayou ◆

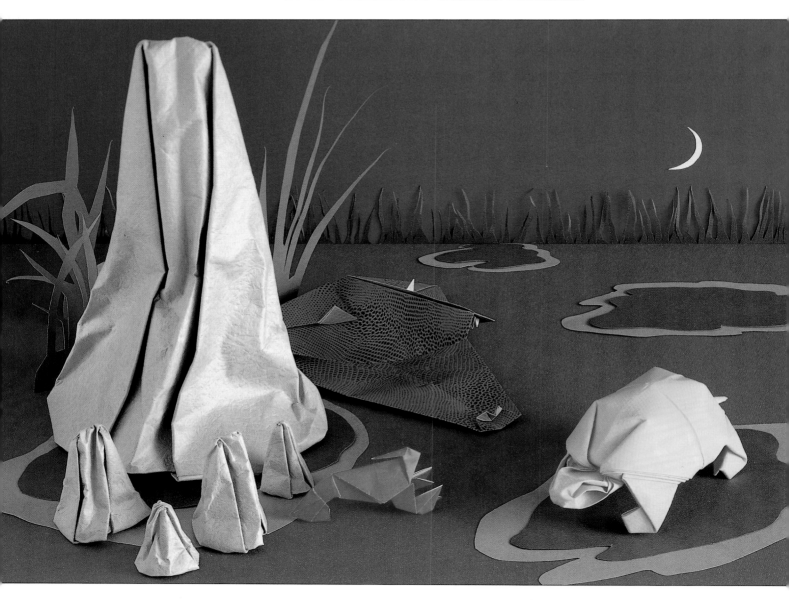

For this project, you will fold the following models:

Name	Page	Rating	Paper requirements
Cypress	47	Easy	One large and several small squares of dark brown paper
Alligator	49	Easy	12 in (30 cm) square of green and yellow paper
Crawfish	52	Low Intermediate	5 in (13 cm) square of thin dark green paper
Turtle	56	High Intermediate	12 in (30 cm) square of thin green paper

◆ cypress ◆

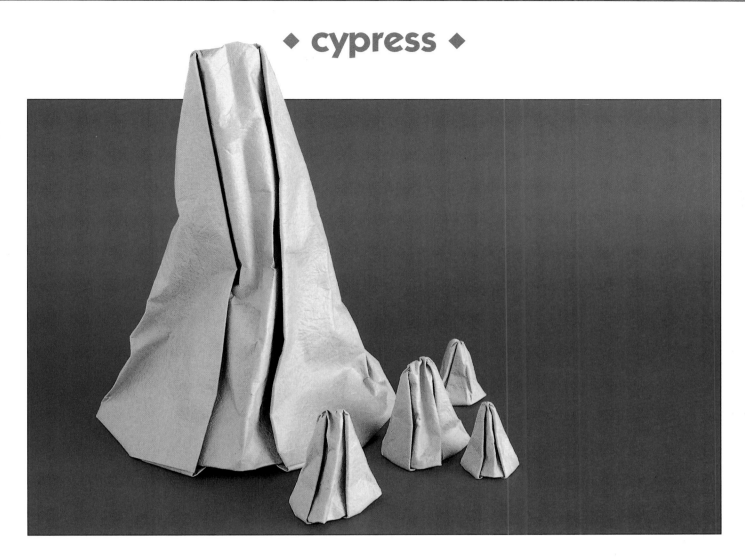

1 Begin with the white side up. Fold the paper in half along the vertical diagonal and unfold.

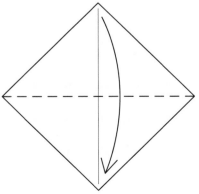

2 Fold the top corner down to the bottom.

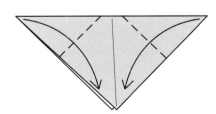

3 Fold the side corners downward, almost all the way to the bottom point. The exact amount isn't critical.

47

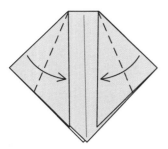

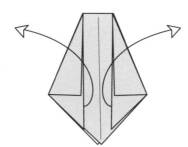

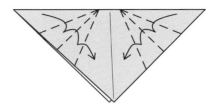

4 Fold the side edges in to lie along the vertical edges.

5 Unfold to the beginning of step 3.

6 Fold the side corners over and over on the existing creases.

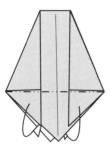

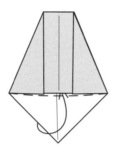

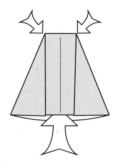

7 Mountain-fold the three near flaps into the inside of the model.

8 Valley-fold the remaining flap up into the model.

9 Open out the bottom of the cone shape and blunt the top corners.

10 Crumple the cone by pushing in the sides all around to give the stump a rough, bark-like texture. You can fold a bit of the bottom underneath so it stands evenly. Make one large shape for the main stump and five to ten smaller ones for the roots.

Finished Cypress.

◆ alligator ◆

1 Begin with the colored side up. Fold the paper in half along both diagonals and unfold.

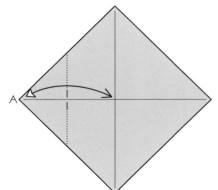

2 Fold point A in to the center and unfold, making the crease sharp only where it crosses the horizontal crease.

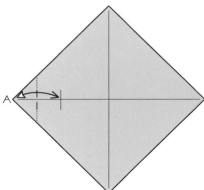

3 Fold point A in to the crease you just made and unfold, making the crease sharp only where it crosses the horizontal crease.

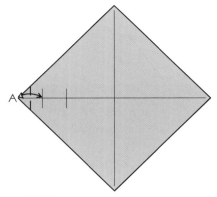

4 Fold point A in to the crease you just made. Unfold. This time, make the crease run all the way across the paper.

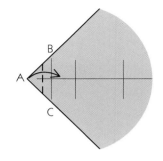

5 This is an enlarged view of the corner. Fold point A in so that crease BC (the crease you just made) cuts across the middle of the white triangle you are making.

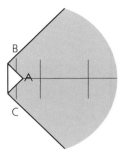

6 This corner is complete. Now repeat steps 3–5 on each of the other three corners.

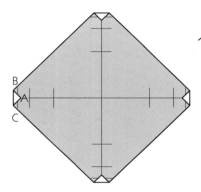

7 Turn the paper over.

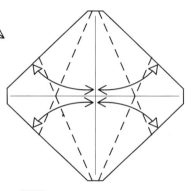

8 Fold each of the four edges in to the center line and unfold.

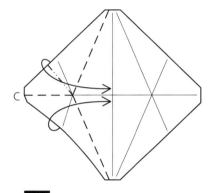

9 Fold the two left edges in to the center together; at the same time, pinch corner D in half. The next step shows this in progress.

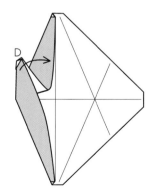

10 Flatten point D upward.

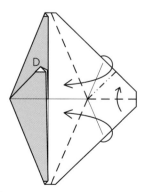

11 Repeat steps 9–10 on the right.

12 Pleat the top and bottom corners—see the next step for a close-up view of the top.

13 Enlarged view of the pleat. Turn the paper over.

14 This shows the completed pleat at the top; the bottom should look the same.

15 Valley-fold the bottom flap upward. The flaps on the back side should be pointing upward. Turn the model over.

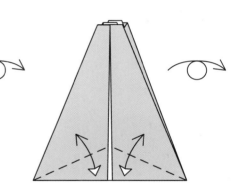

16 Mountain-fold the white corners underneath.

17 Turn the model over.

18 Fold and unfold through all layers. Turn the model back over.

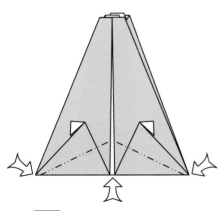
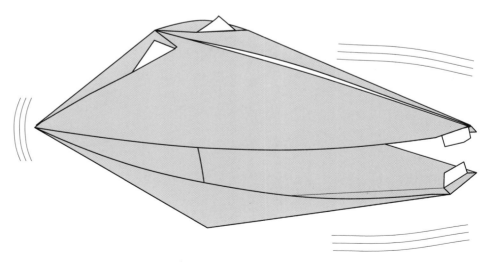

19 Dent the bottom edge upward and simultaneously push in the side corners. The model will become three-dimensional and will open and close its jaws.

Finished Alligator.

◆ crawfish ◆

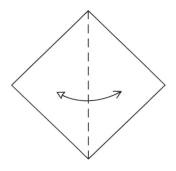

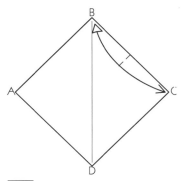

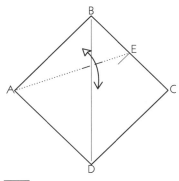

1 Begin with the white side up. Fold and unfold along the diagonal.

2 Fold corner B down to corner C; pinch along the edge and unfold.

3 Make a crease that runs from point A to point E, making it sharp only where it crosses the diagonal crease BD.

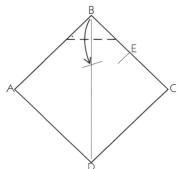

4 Fold corner B down to the intersection of the crease you just made with the diagonal BD.

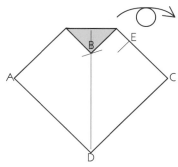

5 Turn the paper over.

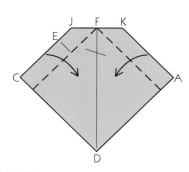

6 Fold edge CJ and AK inward.

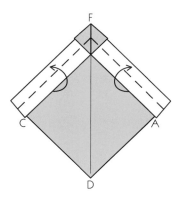

7 Fold the raw edge of the paper back up to lie along the folded edge on each side.

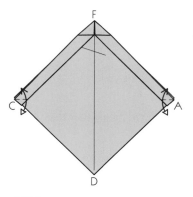

8 Fold the corner of the pleated flap to edge CF and unfold. Repeat on the right.

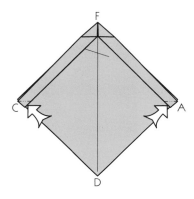

9 Reverse-fold the corners on the creases you just made.

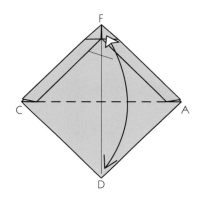

10 Fold corner F down to corner D and unfold. Turn the paper over.

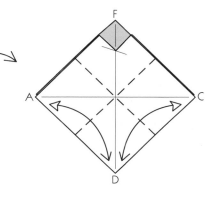

11 Fold edge AF to DC and unfold. Fold edge FC to AD and unfold.

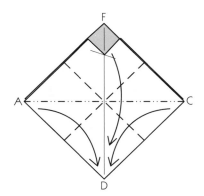

12 Bring corners A, F, and C together at the bottom at corner D.

13 Fold edges GF and HF in to the center line and fold point I down over them; unfold. Repeat behind.

14 Petal-fold flap F upward, letting the small flaps at points A, D, and C swing out to the sides. Petal-fold flap D behind as well.

15 Open out edges L and M near the top of the model. This is easier if you allow points A and C to open slightly.

16 Pull the trapped paper out from flap F; spread the paper and flatten at the top. New creases will be formed along the top edge.

17 Close the model up again.

18 Fold the corners to the outside. The creases meet at the corner (inside).

19 Bring flap B to the front.

20 Squash-fold the two edges.

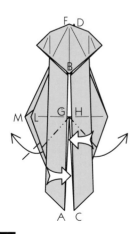

21 Reverse-fold flap A to the left. Note that the flap goes between layers L and M. Repeat on the right with flap C.

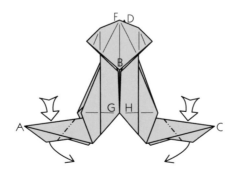

22 Reverse-fold flaps A and C downward, keeping the small, protruding flap to the front.

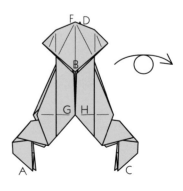

23 Turn the model over.

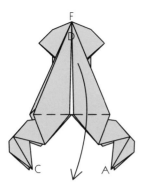

24 Fold flap D down.

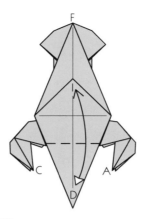

25 Fold flap D up to point I; crease and unfold.

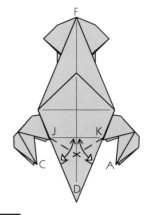

26 Fold edge JD up to the crease you just made (JK) and unfold. Repeat on the right with edge KD.

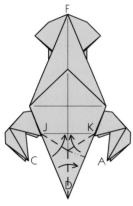

27 Fold a rabbit ear from corner D and fold it over to the right.

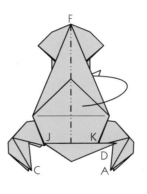

28 Mountain-fold the model in half, allowing point D to stand up from the body. Rotate the model 1/4 turn counterclockwise.

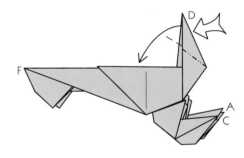

29 Reverse-fold corner D.

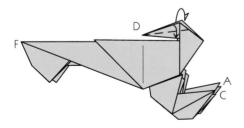

30 Narrow the antennae (point D) with valley folds.

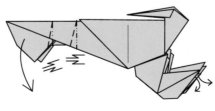

31 Crimp the tail downward. Open each claw.

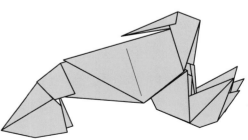

Finished Crawfish.

◆ turtle ◆

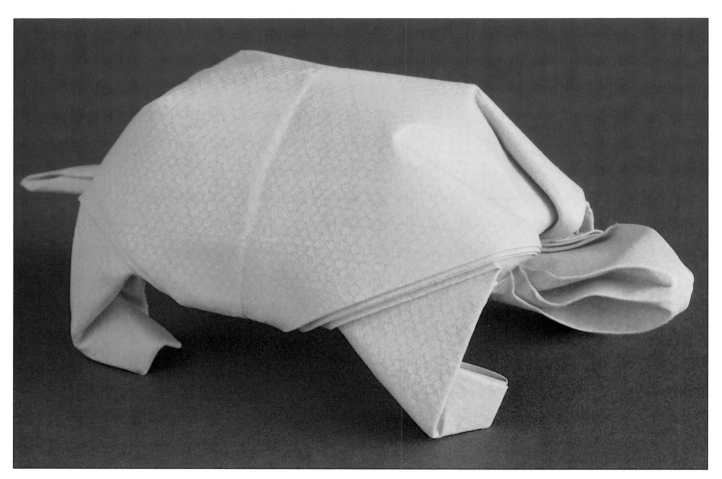

1 Begin with the white side up. Fold the paper in half vertically and unfold. Then fold the sides in to the center line, crease the lower part, and unfold.

2 Fold corner A up to lie on line BD. Note that the crease hits the bottom edge of the paper at point C, the middle of the bottom edge. Repeat on the right side.

3 Turn the paper over.

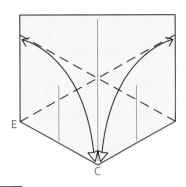

4 Fold corner C up to lie along the left edge—the crease runs through point E. Unfold. Repeat on the right.

5 Turn over the paper.

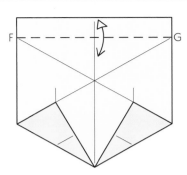

6 Fold down the top edge along a crease running between points F and G (where the two diagonal creases hit the edges). Unfold.

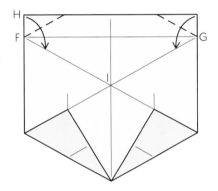

7 Fold down corner H to lie on line FI; the crease hits the edge at point F. Repeat on the right.

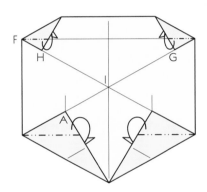

8 Fold corners A and H underneath. Repeat on the right. (This is easily done by unfolding flap A, making the fold, and refolding.)

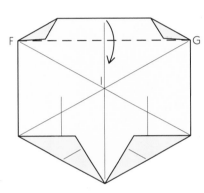

9 Fold the top edge down along the existing crease FG.

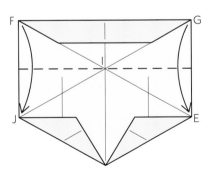

10 Fold down corners F and G to meet corners J and E, respectively.

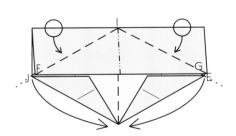

11 Bring corners J, F, G, and E together at the bottom of the model (it will not lie flat).

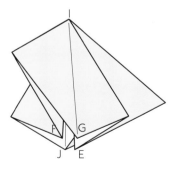

12 Flatten the paper out. Note that the top flap swings to the left and the rear flap swings to the right.

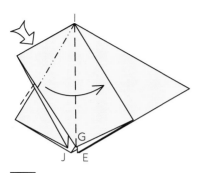

13 Squash-fold the top flap.

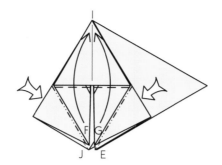

14 Squash-fold each side. Corners F and G get folded up to point I.

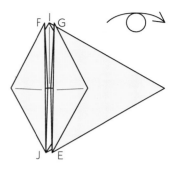

15 Turn the model over from side to side.

16 Squash-fold the large point.

17 Reverse-fold the side corners.

18 Turn the model over from side to side.

19 Reverse-fold two points to the right.

20 Repeat on the left.

21 Reverse-fold all four points.

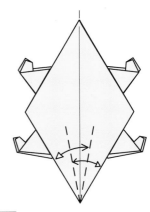

22 Reverse-fold the bottom pair of points upward. Be sure that point I (the thick point) is at the top.

23 Reverse-fold the tips of all four points. Turn the model over.

24 Fold the bottom point (the tail) in thirds and unfold. You don't need to make the creases run all the way up.

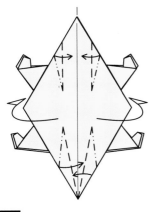

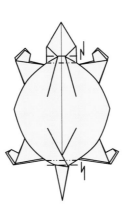

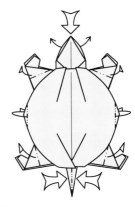

25 Curve the sides of the body away from you; at the same time, crimp the top and bottom of the model. On the bottom, the two edges overlap one another. On the top, they meet in the middle. The shell will bulge upward in the middle.

26 Pleat the neck and tail. This locks the crimps from step 25 in place.

27 Final shaping. Pull out the middle layers of the head and puff it up slightly. Fold the feet down. Pinch the tail in half. Mountain-fold the sides of the shell and round it out.

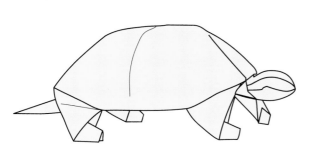

Finished Turtle.

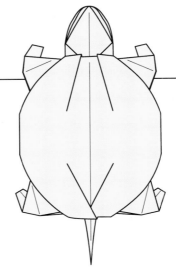

◆ ocean ◆

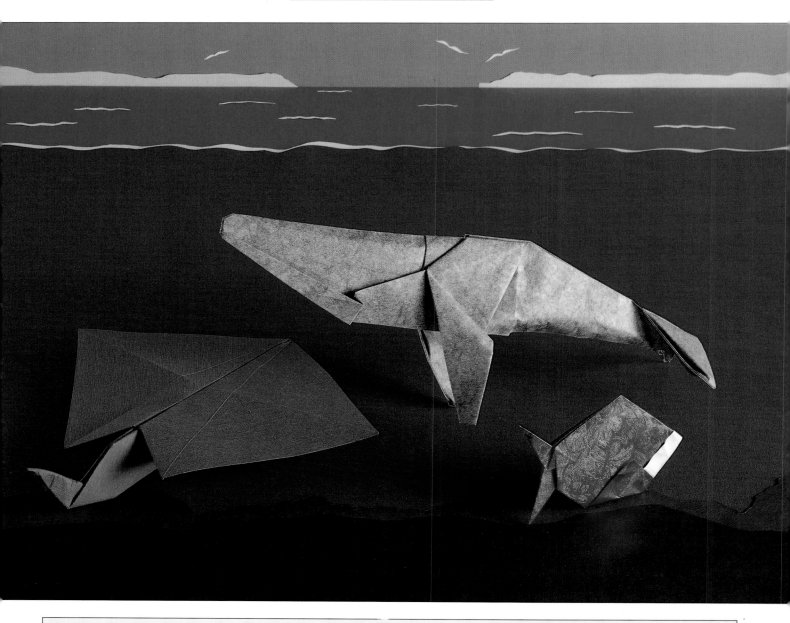

For this project, you will fold the following models:

Name	Page	Rating	Paper requirements
Fish	61	Easy	4 in (10 cm) square of blue paper
Skate	63	Low Intermediate	10 in (25 cm) square of gray paper
Gray Whale	65	High Intermediate	20 in (50 cm) square of gray paper

◆ fish ◆

designed by Karen Reeds

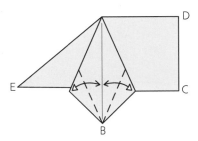

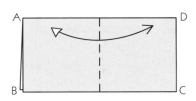

1 Begin with the white side up. Fold the paper in half from top to bottom.

2 Fold edge AB over to edge DC and unfold.

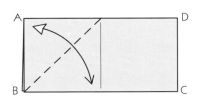

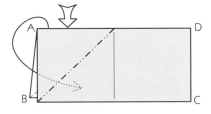

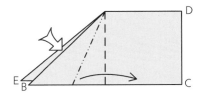

3 Fold down edge AB to edge BC and unfold.

4 Reverse-fold corner A down inside the model on the existing creases.

5 Squash-fold corner B symmetrically.

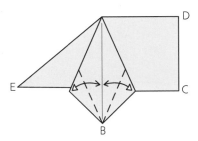

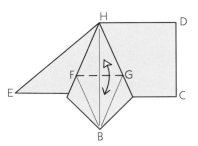

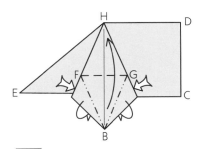

6 Fold in the raw edges to the center and unfold.

7 Fold down point H to point B along a crease that connects points F and G, folding through all layers of the model. Unfold.

8 Petal-fold point B up to point H, using the existing creases.

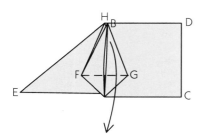

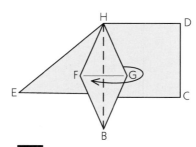

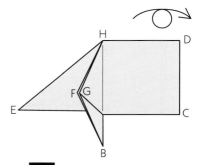

9 Fold point B back down.

10 Fold corner G to the left.

11 Turn over the model.

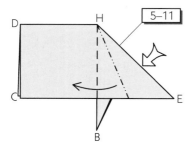

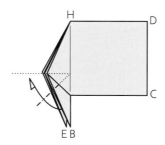

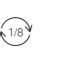

12 Repeat steps 5–11 on flap E (including turning the paper over at the end).

13 Mountain-fold point B underneath and to the left. Rotate the model 1/8 turn clockwise.

14 Mountain-fold the bottom corners inside. There are no reference points for these folds.

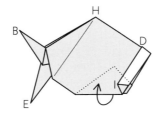

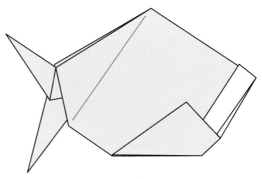

15 Outside-reverse-fold the right edge of the model. (If you spread corners I and J apart, this can be done with a valley fold that runs all the way from I to J.)

16 Tuck the near layer of the model underneath the colored flap inside.

Completed Fish.

◆ skate ◆

designed by Wayne Rickard

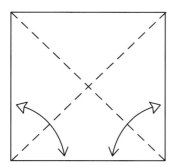

1 Begin with the white side up. Fold the paper in half along the diagonals and unfold.

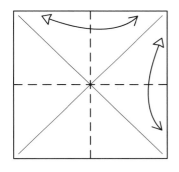

2 Fold the paper in half vertically and horizontally.

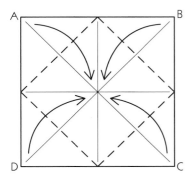

3 Fold the four corners to the center.

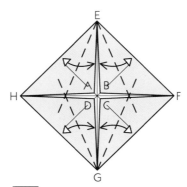

4 Fold edge HG in to lie along the center line EG; crease through both layers and unfold. Repeat on each of the other four edges.

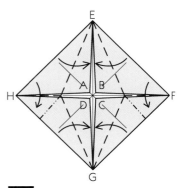

5 Fold a rabbit ear from corners H and F, using the existing creases.

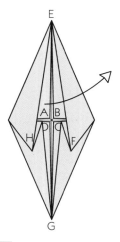

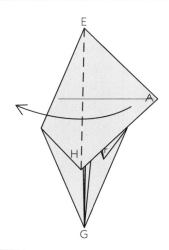

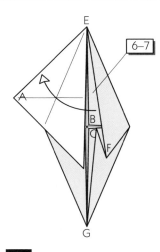

6 Pull corner A out completely.

7 Fold corner A back to the left.

8 Repeat steps 6–7 on corner B.

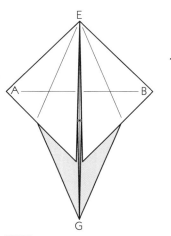

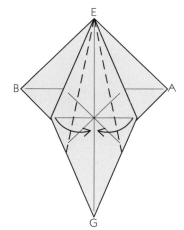

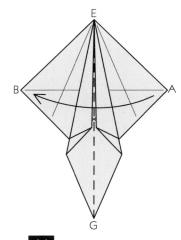

9 Turn the model over.

10 Fold the inner edges in to the center.

11 Fold the model in half.

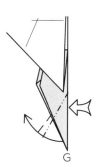

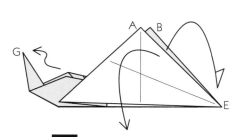

12 Reverse-fold corner G to the left. Then rotate the model 1/4 turn clockwise.

13 Fold corners A and B down to the sides and spread them out. Curl the tail (point G).

Finished Skate.

◆ gray whale ◆

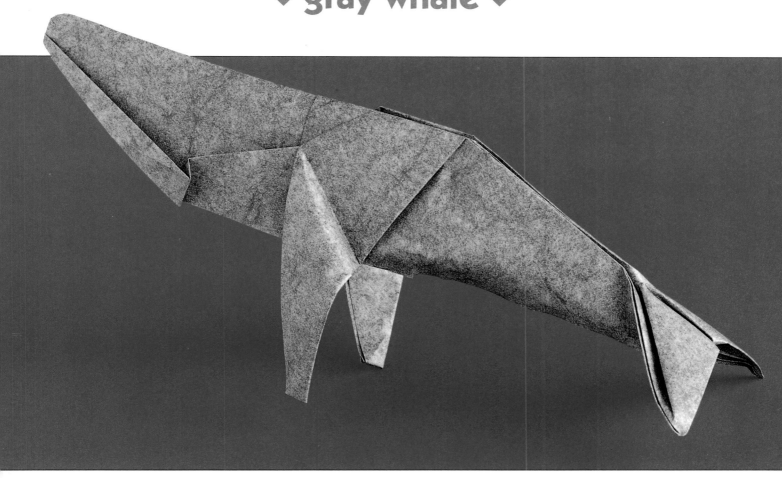

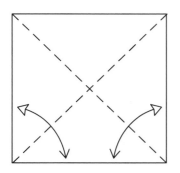

1 Begin with the white side up. Fold the paper in half along the diagonals and unfold. Turn the paper over.

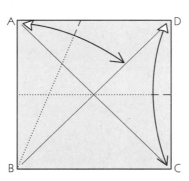

2 Fold edge AB over to lie along the diagonal BD, making the crease sharp only where it hits the top edge (AD). Then fold corner D down to corner C, making the crease sharp only where it hits the right edge (CD).

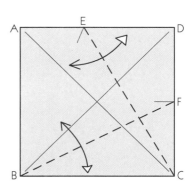

3 Fold corner D down so that the crease runs from corner C to point E and unfold. Fold corner C up so that the crease runs from corner B to point F and unfold.

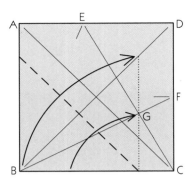

4 Point G marks the intersection of the two creases you just made. Fold corner B up to lie on the diagonal BD while the bottom edge BC runs through point G.

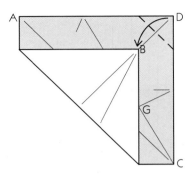

5 Fold corner D down to corner B.

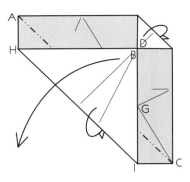

6 Mountain-fold edge HI behind with the crease running along AC, allowing corner B to swing down to the left. Fold corner D behind as well.

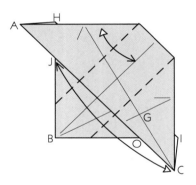

7 Fold corner C up to point J and unfold. Fold point A down to point O and unfold.

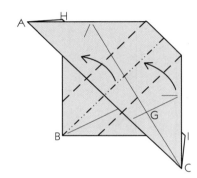

8 Pleat the model using the creases you just made. Rotate 1/8 turn clockwise.

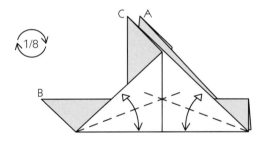

9 Fold and unfold through a single layer of paper. Repeat behind.

10 Fold a rabbit ear and bring point C down to corner K. Repeat behind on point A.

11 In progress.

12 Fold and unfold. Repeat behind.

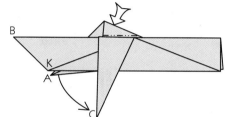

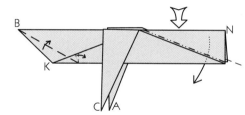

13 Squash the top of edge LM; pinch edge CM in half on the crease you just made (changing it to a mountain fold) and swing it downward.

14 Repeat behind on flap A.

15 Valley-fold corner K upward. Pull the excess paper to the right and pinch flat. Repeat behind. Reverse-fold corner N downward.

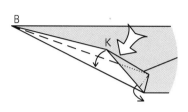

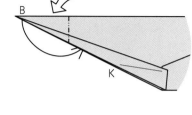

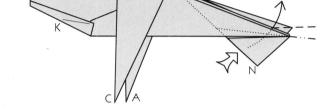

16 Enlarged view of head. Valley-fold corner K downward and pull out the pocket at the lower right to lie flat. Repeat behind.

17 Reverse-fold corner B.

18 Reverse-fold corner N upward.

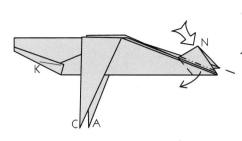

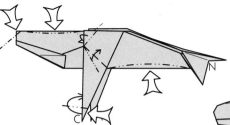

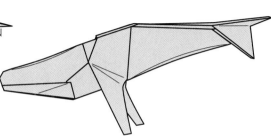

19 Squash-fold the tail (corner N) and spread the flukes.

20 Reverse-fold the nose and the tips of the pectoral flukes. Round the body and forehead, and lift and curve the pectoral flukes.

Finished Gray Whale.

◆ Arctic ice ◆

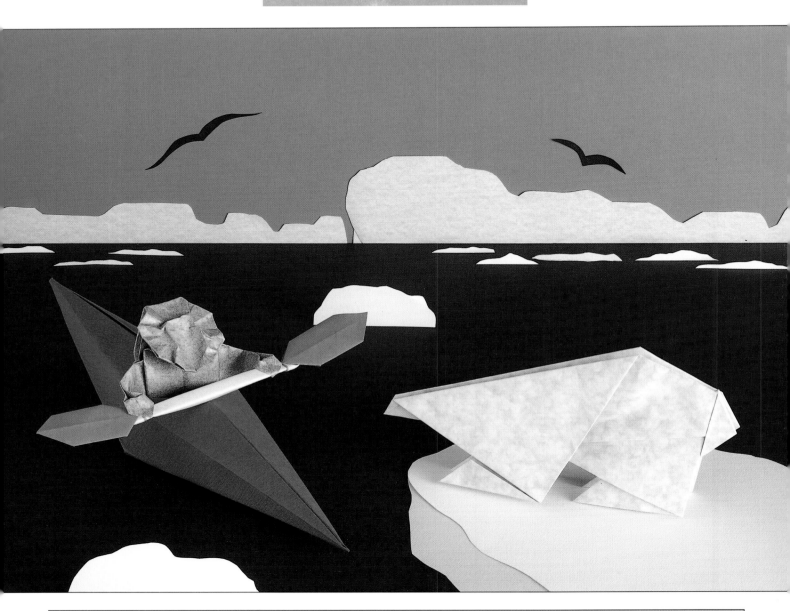

For this project, you will fold the following models:

Name	Page	Rating	Paper requirements
Paddle	69	Easy	6 in (15 cm) square of brown paper
Kayak	71	High Intermediate	10 in (25 cm) square of thin brown paper
Eskimo	74	High Intermediate	12 in (30 cm) square of gray paper
Polar Bear	78	Low Intermediate	12 in (30 cm) square of white or ivory paper

◆ paddle ◆

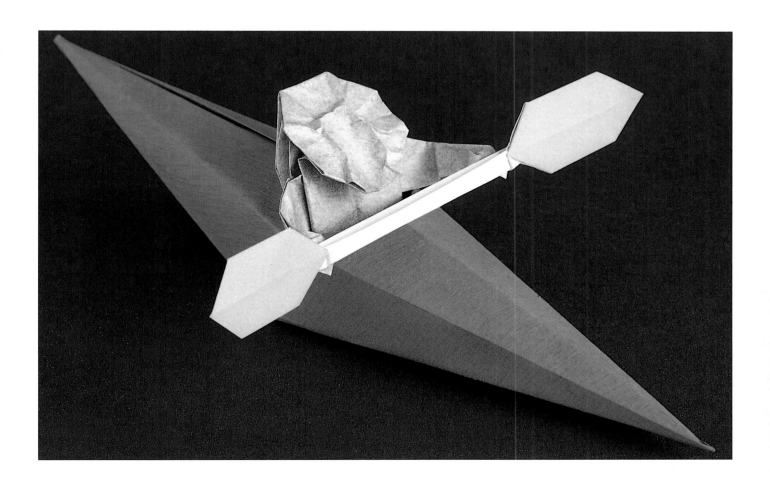

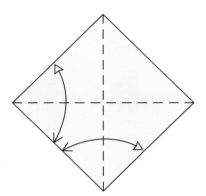

1 Begin with the colored side up. Crease the diagonals.

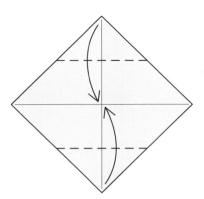

2 Fold the top and bottom corners to the center of the paper.

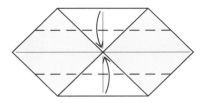

3 Fold the top and bottom edges to the horizontal crease. Be sure that the two corners stay touching in the middle.

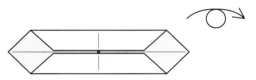

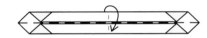

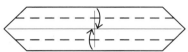

4 Turn the model over.

5 Fold the top and bottom edges to the horizontal crease.

6 Fold down the top half over the bottom.

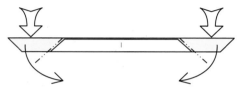

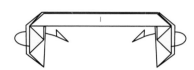

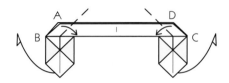

7 Reverse-fold the ends downward on a crease that runs along the border between the white and colored regions.

8 Fold the rear layer of each of the downward-pointing flaps behind and toward the center.

9 Fold down corners A and D to lie on edge BC; the two downward-pointing flaps swing out to the sides.

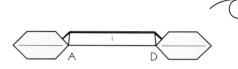

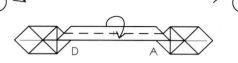

10 Turn the model over.

11 Fold the handle in half again. Turn the model over.

12 Finished Paddle.

◆ kayak ◆

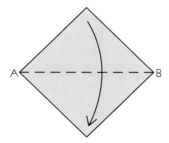

1 Begin with the colored side up. Fold down the top corner to the bottom along line AB.

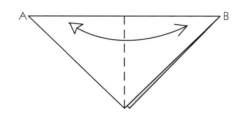

2 Fold the left corner (A) over to the right (B) and unfold.

3 Fold in edge AD to lie along the center line CD. Fold edge BD in the same way.

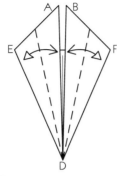

4 Fold in edges ED and FD to meet at the center line; crease firmly and unfold.

5 Squash-fold point A down to lie on line ED. Repeat on the right on point B.

6 Fold corners A and B up as far as possible.

7 Turn over the model.

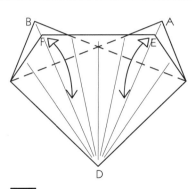

8 Fold down corner F, crease, and unfold. Repeat on the right on corner E.

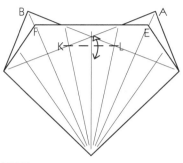

9 Make a crease that connects points K and L. Fold through all layers, crease firmly, and unfold.

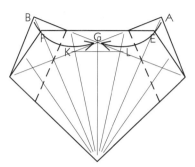

10 Fold point B in to point G, which is the intersection of the two creases you made in step 8. Repeat on the right with point A.

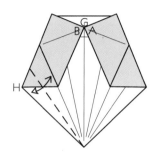

11 Fold corner H in on an existing crease, crease firmly and unfold.

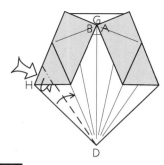

12 Reverse-fold corner H and fold in edge HD on the crease you just made. Do not repeat on the right.

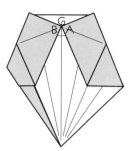

13 Turn over the model.

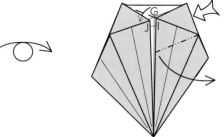

14 Squash-fold the upper right edge. Look at step 15 to see the final position of corner I. Note also that the top edge goes underneath corner J.

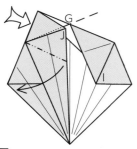

15 Squash-fold the upper left edge in the same way. Note that corner I landed on an existing crease; corner J does the same.

16 Reverse-fold the edge just as you did in steps 11–12. Do not repeat on the right.

17 Turn over the model.

18 Carefully fold down the thick point on the crease you made in step 9.

19 Fold the rear layer upward, pushing down on the two corners; the model will not lie flat.

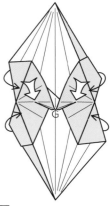

20 Push down on the two corners shown and bring the edges toward you; the model "pops" inside-out. It should end up with the bulge away from you.

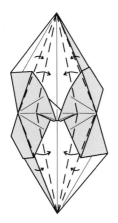

21 Crease each of the valley folds sharply through all layers.

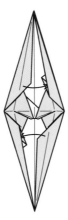

22 Tuck the wider flap on each side into the pocket on the other side.

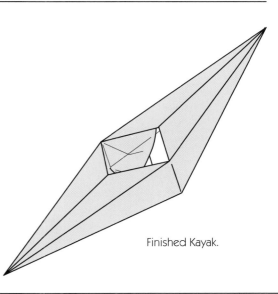

Finished Kayak.

◆ eskimo ◆

1 Begin with the colored side up. Crease both diagonals. Then turn the paper over.

2 Fold the paper in half along the other two directions and unfold.

3 Push in the center of the paper and bring corners A, B, and C together at the bottom point D.

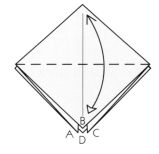

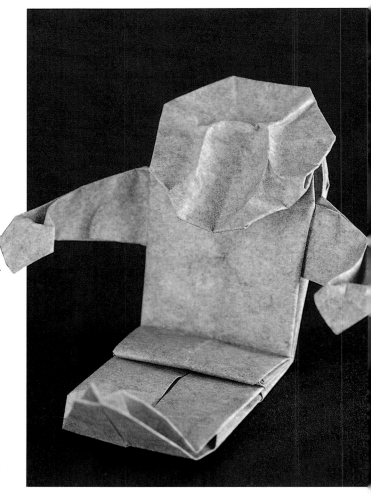

4 Flatten the model.

5 Fold point B (single layer only) up to the top and unfold.

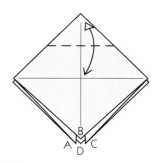

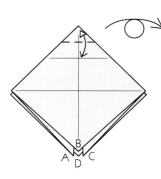

6 Fold the top point down to the crease you just made and unfold.

7 Fold the top point down to the crease you just made; crease firmly and unfold. Turn the model over.

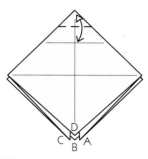

8 Fold the top point down on the same crease; crease firmly and unfold. Do this on both sides of the paper several times until the point folds easily in either direction.

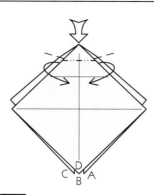

9 Pull the near edges toward you and press down on the top point so that it begins to flatten out. Try to keep points A–D together at the bottom.

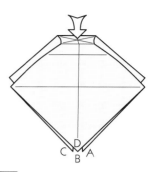

10 Push the flat part down inside the model, changing the direction of some of the creases.

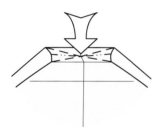

11 Close-up view showing the creases. Push down the middle and flatten the model.

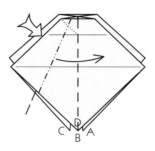

12 Squash-fold the edge by following steps 13–14.

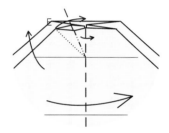

13 First, squash-fold the tiny pocket at the top. It helps to put a pencil or other sharp point inside to spread the layers.

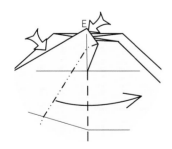

14 Then squash-fold the main edge. point·E disappears in the process. The left flap will come to the center.

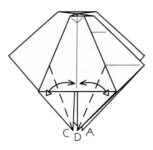

15 Fold a single edge to the center line on each side. Unfold.

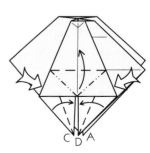

16 Push in the sides and fold the center of the exposed edge up in a petal fold. (It helps to pre-crease the horizontal valley fold.)

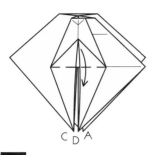

17 Fold the small point back down.

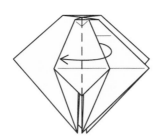

18 Fold one narrow layer to the left.

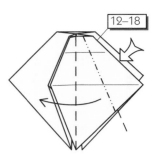

19 Repeat the squash and petal folds of steps 12–18 on the right and on both flaps behind.

20 Fold in one corner to the center line on each side.

21 Fold one narrow layer and one wide layer to the left.

22 Fold in one corner on each side to the center line.

23 Fold one layer to the right.

24 Tuck the point underneath and turn the model over.

25 Fold one point up.

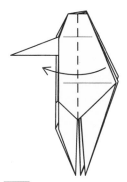

26 Fold in one corner on each side and fold up the left point on the bottom.

27 Fold one layer to the left while you fold down the top corner and pinch it in half.

28 Fold one layer to the left.

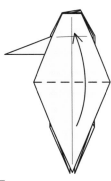
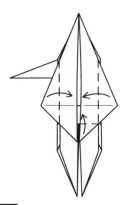
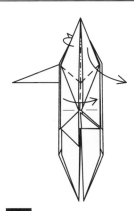

29 Fold up one flap.

30 Fold in one corner on each side and fold up the right point on the bottom.

31 Fold one layer to the right while you fold down the top corner and pinch it in half.

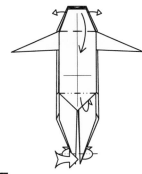
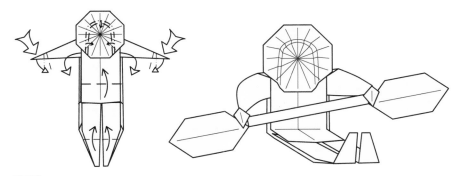

32 Open out the top of the model. Tuck the bottom point up underneath. Reverse-fold the tip of each of the two bottom points.

33 Pleat a single layer of paper all the way around the head. Squash-fold the hands and curve the arms around toward the front. Fold the feet up. (If you are putting the Eskimo into a kayak, bend him at the waist.)

Finished Eskimo.

◆ polar bear ◆

designed by Marc Kirschenbaum

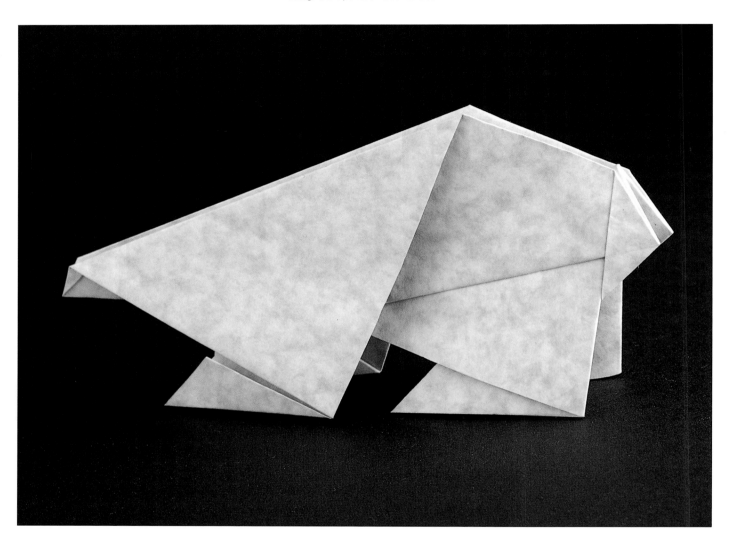

1 Begin with the colored side up. Fold the paper in half and unfold.

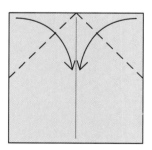

2 Fold down the top edges to meet along the vertical crease.

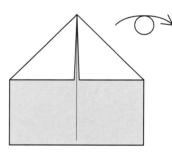

3 Turn over the model.

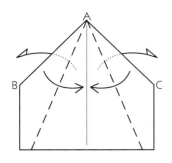

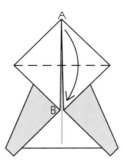

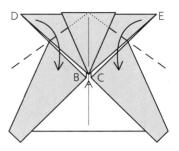

4 Fold in edges AB and AC to meet along the vertical center line; allow the two flaps of paper behind to swing out to the sides.

5 Fold point A down to point B.

6 Valley-fold corners D and E down. Note that the crease runs all the way up under the pocket, and it hits the edge where two edges come together.

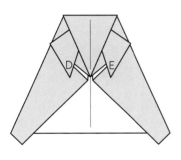

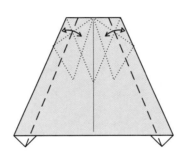

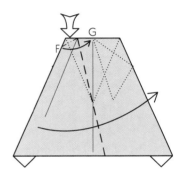

7 Turn the model over.

8 Crease lightly with valley folds. Note that near the top of the model, each crease crosses the intersection of two hidden edges.

9 Squash-fold the upper left corner and fold the left side up to the right. You should adjust the fold so that point F hits point G.

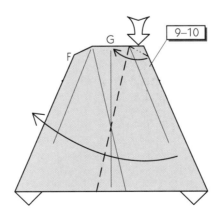

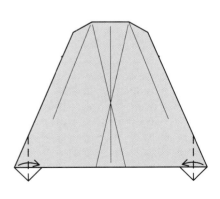

10 Fold the flap back to the left, but keep the squash fold at the top in place.

11 Repeat steps 9–10 on the right.

12 Fold the bottom corners in half.

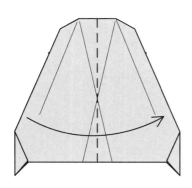

13 Fold the model in half.

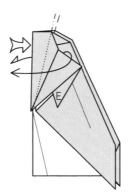

14 Push in the top of the left edge; at the same time, swing points E and D (behind) to the left. Flatten.

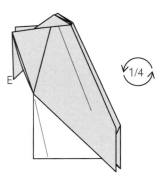

15 Rotate the model 1/4 turn counterclockwise.

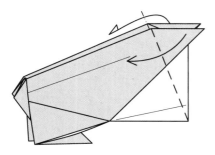

16 Fold one point to the left in front and one to the right behind.

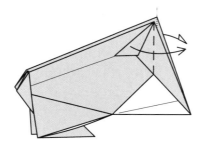

17 Fold one point to the right in front and behind.

18 Fold down the top edges so that the small flaps (the feet) line up with the rear feet.

Finished Polar Bear.

◆ Australian forest ◆

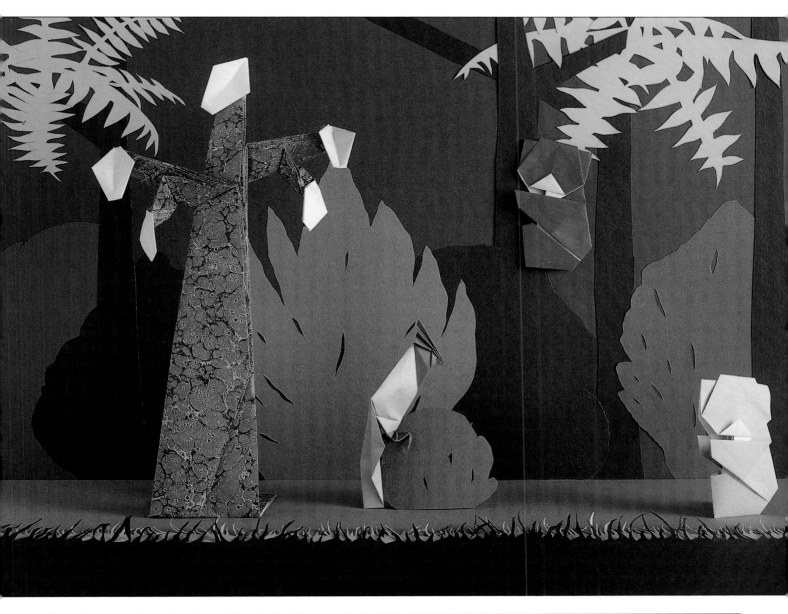

For this project, you will fold the following models:

Name	Page	Rating	Paper requirements
Koala	82	Low Intermediate	6 in (15 cm) square of brown and white paper.
Gum Tree	86	High Intermediate	20 in (50 cm) square of green and brown paper
Cockatoo	90	High Intermediate	6 in (15 cm) square of white and yellow paper

◆ koala ◆

designed by Edwin Corrie

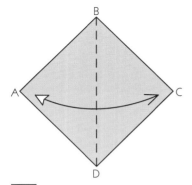

1 Begin with the colored side up. Fold the paper in half along one diagonal and unfold.

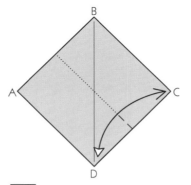

2 Fold edge AD up to edge BC; pinch at the right (along edge DC) and unfold.

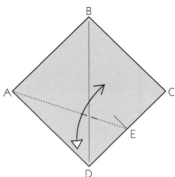

3 Fold edge AD up to form a crease running from point A to point E, making the crease sharp only where it crosses the diagonal BD. Unfold.

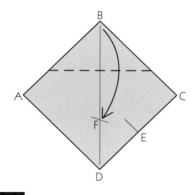

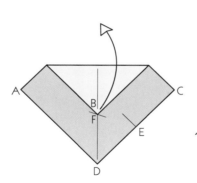

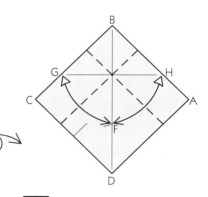

4 Fold down point B to the intersection of the two creases (point F).

5 Unfold point B and turn the paper over.

6 Fold edge BC so that point G lands on point F and unfold. Repeat on the right with edge BA and point H.

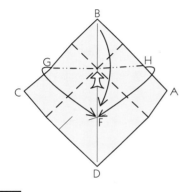

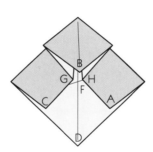

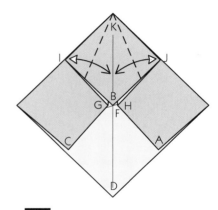

7 Push down in the middle while you bring points G, B, and H together at point F.

8 Flatten the model.

9 Fold in edges IK and JK (the two flaps at the top) to lie along the center line BK. Unfold.

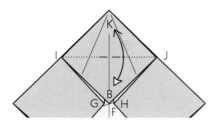

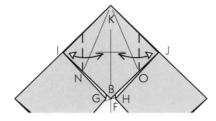

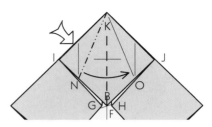

10 Fold corner B up to point K; pinch in the middle and unfold.

11 Fold in corners I and J so that the new creases hit points N and O and points I and J lie on the horizontal crease you just made (they will not meet in the middle). Unfold.

12 Squash-fold edge IK.

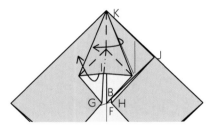

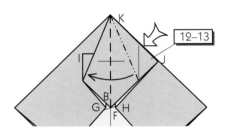

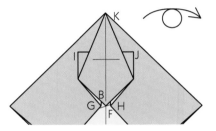

13 Close up the squash fold while you lift up point I. The valley folds lie on existing creases.

14 Repeat steps 12–13 on the right.

15 Turn over the model.

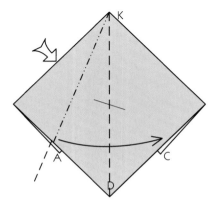

16 Squash-fold the left edge.

17 Fold the squashed edge to the left.

18 Squash-fold the right edge.

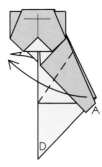

19 Fold corner C to the left and turn over the model.

20 Mountain-fold corner K behind. Fold up corner B.

21 Fold flap A over to the left so that its upper edge is horizontal and parallel to the bottom of the nose. Fold the corresponding flap behind to match.

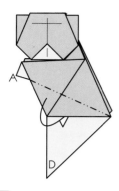

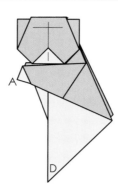

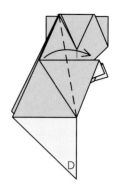

22 Mountain-fold the corner underneath.

23 Turn over the model.

24 Fold one layer to the right. Be careful that the two flaps at the right (the forelegs) remain matched.

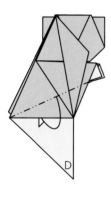

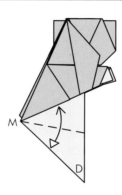

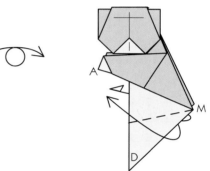

25 Mountain-fold the corner underneath.

26 Fold edge MD up to the folded edge, crease, and unfold. Turn over the model.

27 Outside reverse-fold point D.

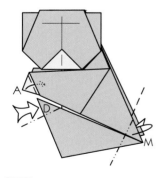

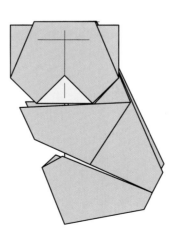

28 Reverse-fold point D. Mountain-fold point M inside; repeat behind. Fold corner A into the pocket; repeat behind.

Finished Koala.

◆ gum tree ◆

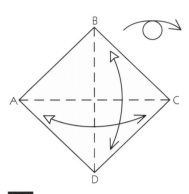

1 Begin with the colored side up. Fold and unfold along the diagonals. Turn over the paper.

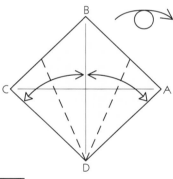

2 Fold in edges CD and AD to meet along the center line; unfold and turn the paper back over.

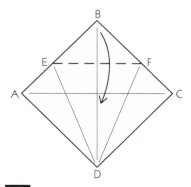

3 Fold corner B down along a crease that runs from point E to point F.

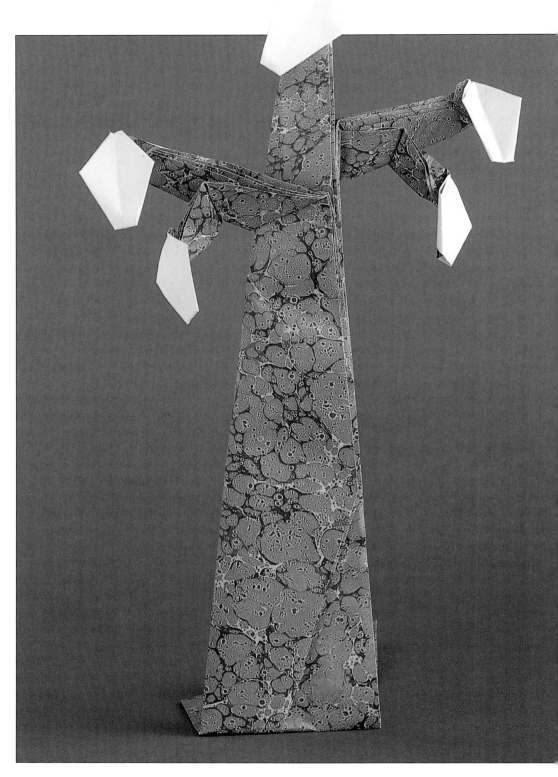

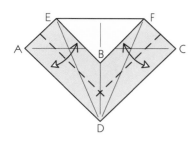

4 Fold edge AD to edge EB and unfold. Fold edge DC to edge BF and unfold.

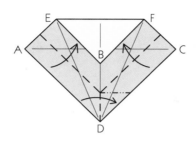

5 Use the creases you just made to fold a rabbit ear from point D.

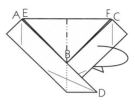

6 Mountain-fold the right half of the model behind.

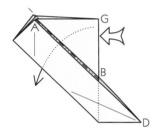

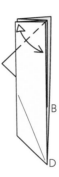

7 Reverse-fold corner G. Rotate the model 1/8 turn clockwise.

1/8

8 Fold and unfold. Repeat behind.

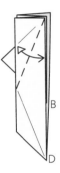

9 Fold and unfold. Repeat behind.

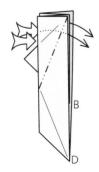

10 Reverse-fold two edges on the creases you made in step 9.

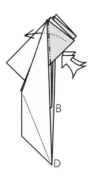

11 Reverse-fold the two edges back to the left.

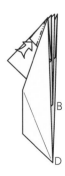

12 Reverse-fold the edge. Repeat behind.

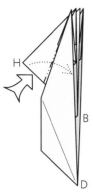

13 Reverse-fold corner H.

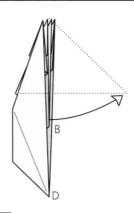

14 Pull corner B (one of the original corners of the square) as far out as possible.

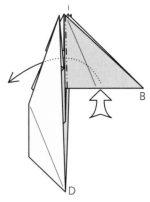

15 Reverse-fold corner B to the left along the center line.

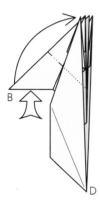

16 Reverse-fold corner B upward to line up with the other points.

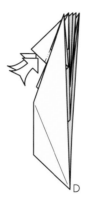

17 Reverse-fold both edges.

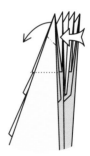

18 This is a close-up of the top of the model; there should be five points at the top. Reverse-fold a little less than half of the near point to the left.

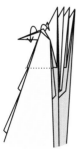

19 Wrap all layers from the inside to the outside. This is much easier if you open out the point, wrap the layers, and then re-fold.

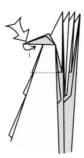

20 Fold the tip of the colored point inside and underneath.

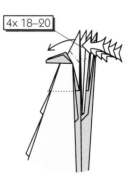

21 Repeat steps 18–20 on the other four flaps.

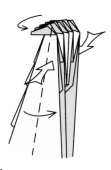

22 Press all the layers together and carefully valley-fold through them all. The colored points at the top swing to the right.

23 Crimp two points downward, folding them together as one. It will be easier if you partially unfold the previous step to accomplish this.

24 Reverse-fold out two more points, folding them together as one.

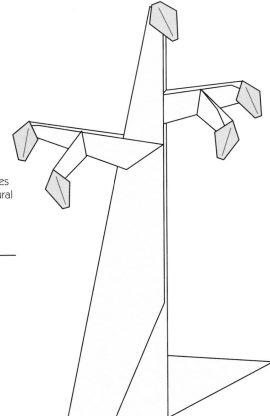

25 Crimp one of the two points downward on each side.

26 Open up each of the leaves and twist them around to a natural position.

27 Mountain-fold a portion of the bottom behind to make a base.

Finished Gum Tree.

◆ cockatoo ◆

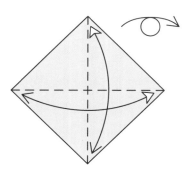

1 Begin with the colored side up. Fold and unfold along the diagonals. Turn the paper over.

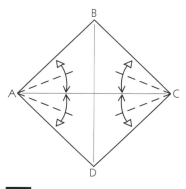

2 Fold edge AB to the horizontal crease AC, making the crease sharp only about halfway to the middle; unfold. Repeat on the other three edges.

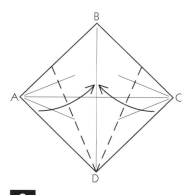

3 Fold in edges AD and CD to the center line.

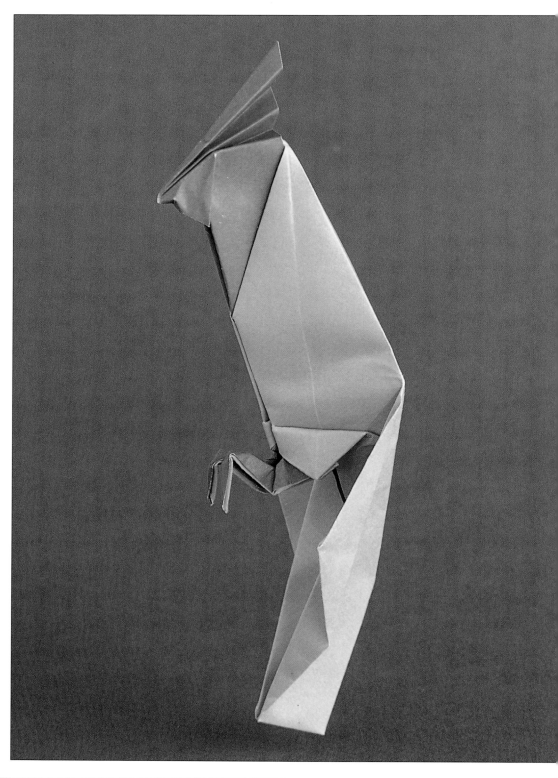

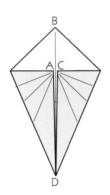
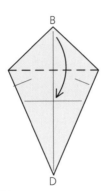
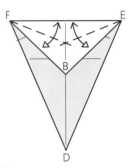

4 Turn over the model.

5 Fold down corner B.

6 Fold edge BF up to the top edge EF and unfold. Repeat on the right with edge BE.

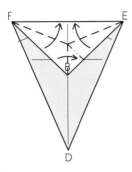
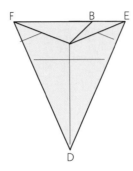
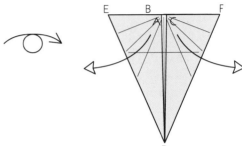

7 Fold a rabbit ear from flap B.

8 Turn over the model.

9 Unfold flaps A and C.

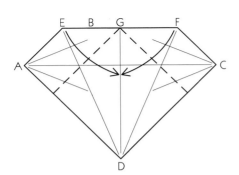
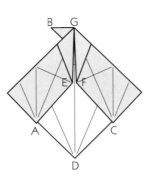
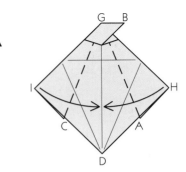

10 Fold edges EG and GF down to meet along the center line.

11 Turn over the model.

12 Fold in edges IG and HG to meet along the center line. Note that the folds run all the way to point G, up under the little hood.

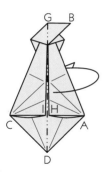

13 Mountain-fold the right side of the model behind.

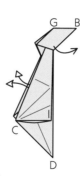

14 Pull the loose layers of paper out of the left side of the model and swivel point B upward and to the right.

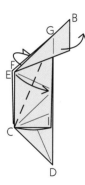

15 Fold corners E and F down to edge GD and swivel point B farther upward.

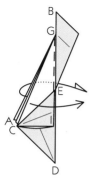

16 Fold corners A and C to the right. Be careful to keep point E (and the corresponding point behind) in place.

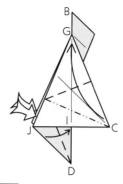

17 Simultaneously fold corner C up to point G and squash-fold corner J in a swivel fold. Repeat behind.

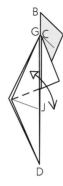

18 Fold and unfold. Repeat behind.

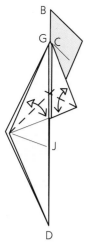

19 Crease flap C along two angle bisectors. Repeat behind.

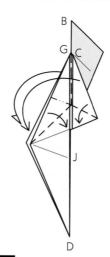

20 Fold a rabbit ear from flap C. Repeat behind.

21 Unfold flap C. Repeat behind.

22 Re-fold the rabbit ear, but pull the right raw edge of the paper as far out as possible as you refold it.

23 Fold the raw edge upward on an existing crease.

24 Fold point C to the right. Repeat behind with point A.

25 Fold point C in half while you fold point K down; you must do these two folds simultaneously. Repeat behind on point A.

26 Fold the corner inside. Repeat behind.

27 Make a crease that runs from point L to point J through the near layer. Repeat behind.

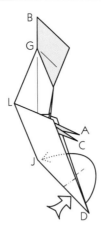

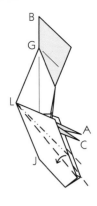

28 Outside-reverse-fold point D to the right on the creases you just made.

29 Reverse-fold point D inside to point J.

30 Pleat the near layer of the tail. Repeat behind.

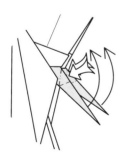

31 Crimp the feet upward.

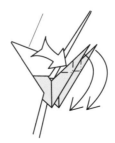

32 Reverse-fold each foot twice so that it points downward.

33 Enlarged view of head. Fold the top point down.

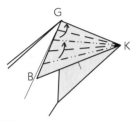

34 Pleat edge BK up to edge GK. The exact number of pleats isn't important, but each crease should run all the way to point K.

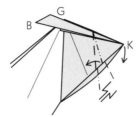

35 Crimp point K downward.

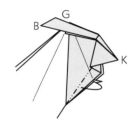

36 Fold the edge under the beak inside. Repeat behind.

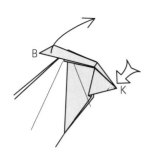

37 Push the tip of the beak down slightly. Lift up the crest (point B) and fan out the pleats.

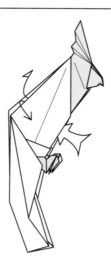

38 Put your finger in the slot in the belly and open out the back to make the body three-dimensional.

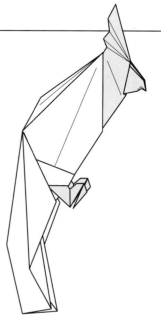

Finished Cockatoo.

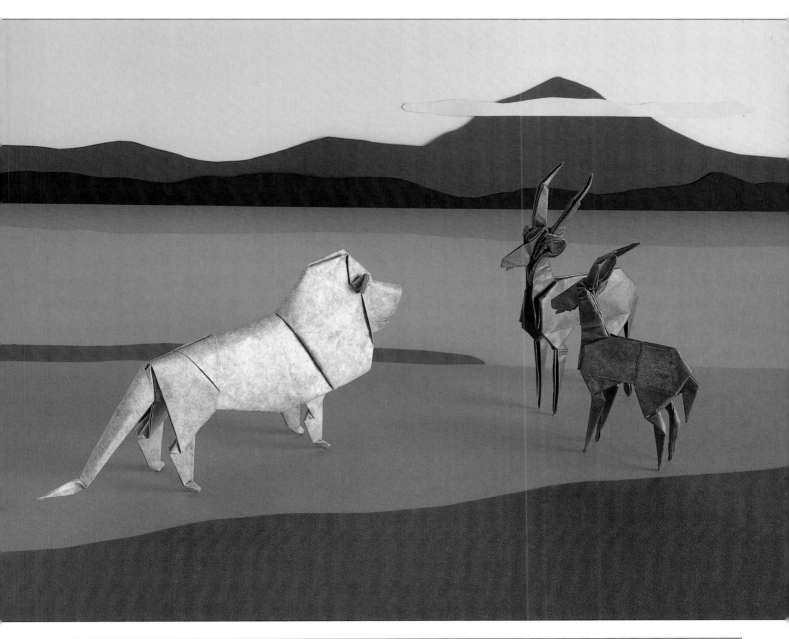

For this project, you will fold the following models:

Name	Page	Rating	Paper requirements
Lion	96	Difficult	16 in (40 cm) square of thin yellow paper
Gazelle	104	Difficult	12 in (30 cm) square of thin brown paper

◆ lion ◆

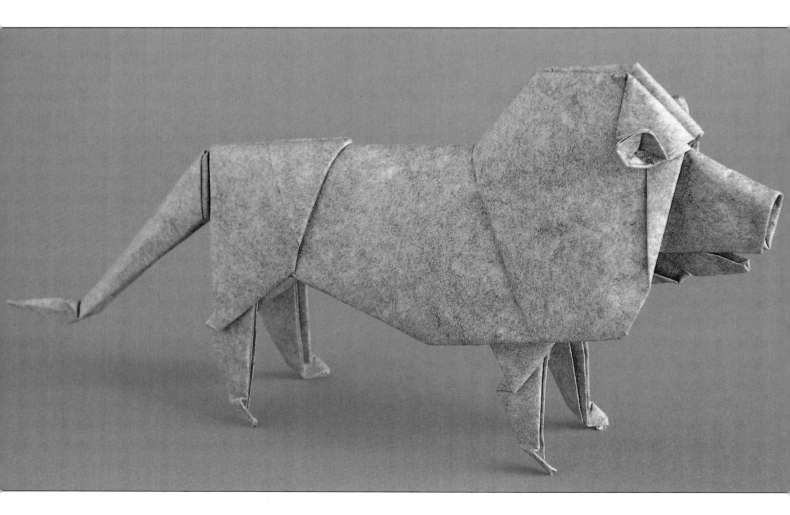

1 Begin with the colored side up. Fold the paper in half along the diagonals and unfold.

2 Fold edge BC up to lie along the diagonal BD and unfold. Then fold corner A down to corner B, making the crease sharp only where it hits the left edge AB.

3 Fold corner B up so that the crease runs from corner C to point E and unfold, making the crease sharp only where it crosses the crease you just made.

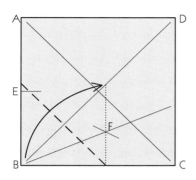

4 Point F marks the intersection of the two creases you just made. Fold corner B up to lie on the diagonal BD while the edge BC runs through point F.

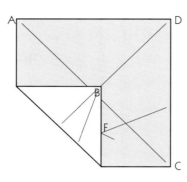

5 Turn over the paper.

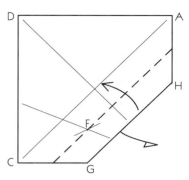

6 Fold edge GH to lie along diagonal CA, allowing corner B to flip out from behind.

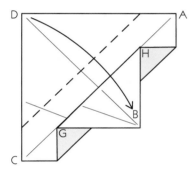

7 Fold down corner D to line up with point B.

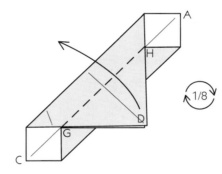

8 Fold corner D back up along crease CA and rotate the model 1/8 turn clockwise.

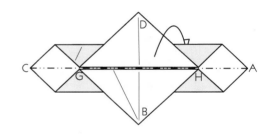

9 Mountain-fold the top half of the model behind and along AC.

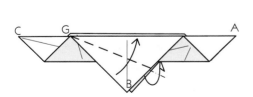

10 Fold up edge GB to lie along edge CA. Repeat behind.

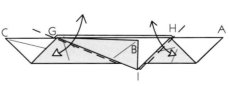

11 Crease through all layers along edges GI and HI. Repeat on the other side.

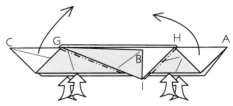

12 Reverse-fold corners C and A upward; you must simultaneously reverse-fold both of the bottom edges on each side.

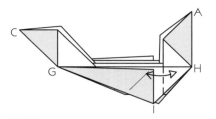

13 Fold corner H to the left and unfold. Repeat behind.

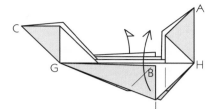

14 Fold corner I up; repeat behind.

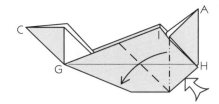

15 Squash-fold corner H; the mountain fold forms on the crease you made in step 13. Repeat behind.

16 Reverse-fold the edge, tucking the excess paper above corner I behind corner I. Repeat behind.

17 Fold the bottom edge up and unfold. Repeat behind.

18 Squash-fold corner A.

19 Petal-fold corner A.

20 Fold point A back to the left.

21 Fold point J in and unfold, creasing through all layers.

22 Fold a layer up.

23 Sink corner J by opening it out flat and pushing the point inside the remaining layers.

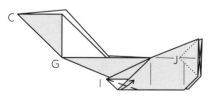

24 Fold the corner up so that the raw edges meet. Repeat behind.

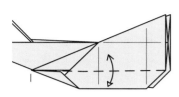

25 Fold the bottom edge up and unfold, creasing through all layers. Repeat behind.

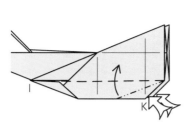

26 Spread-sink corner K as you fold the bottom edge up. Repeat behind.

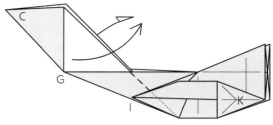

27 Fold corner G up to the right. Repeat behind.

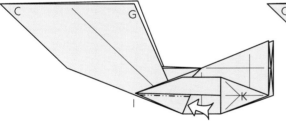

28 Reverse-fold the edge. Part of the reverse fold runs behind flap G. Repeat behind.

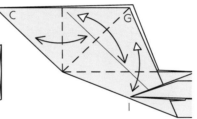

29 Fold and unfold on both sides of the paper.

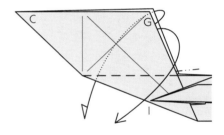

30 Turn flap C inside-out.

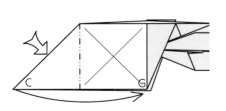

31 Reverse-fold flap C to point G.

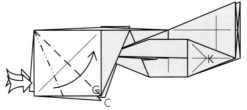

32 Squash-fold the left edge; repeat behind.

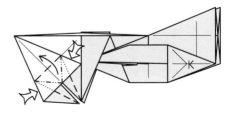

33 Petal-fold the edge. Repeat behind.

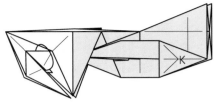

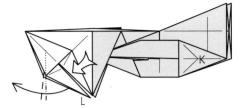

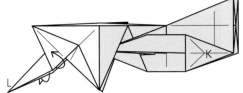

34 Tuck the petal fold inside.

35 Reverse-fold point L as far as possible to the left.

36 Wrap one layer to the front. Repeat behind.

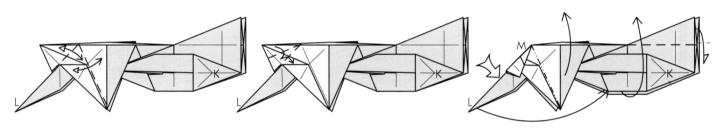

37 Fold and unfold through all layers.

38 Fold the thick point over and over.

39 Squash-fold flap L as you open the model out flat. The mountain folds run to point M.

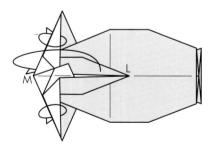

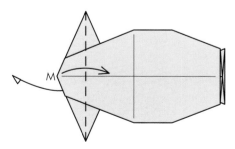

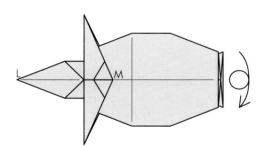

40 Turn corner M inside-out and fold point L to the rear.

41 Fold corner M to the right and allow flap L to swing out from behind.

42 Turn the model over from top to bottom.

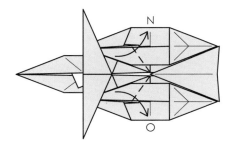

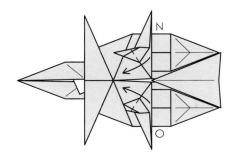

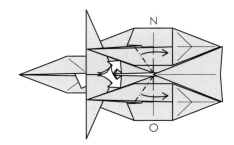

43 Untuck the two flaps trapped in the legs and fold them to align with line NO. A gusset forms along the left side of each flap.

44 Fold the two points back to the left, leaving the gussets in place.

45 Squash-fold the two points on existing creases.

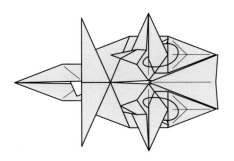

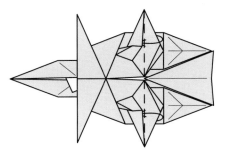

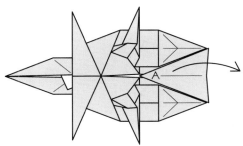

46 Fold one layer from front to back on each point.

47 Tuck half of each point into the pocket.

48 Fold point A to the right.

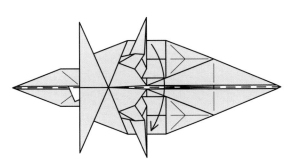

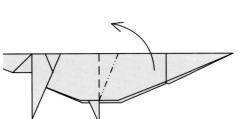

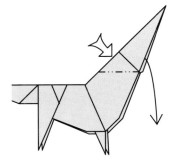

49 Fold the model in half.

50 Crimp the right side of the model upward.

51 Reverse-fold the right side downward.

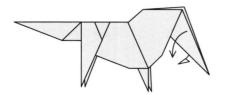

52 Fold down one layer of the head on each side.

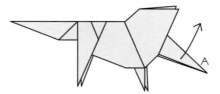

53 Slide point A upward.

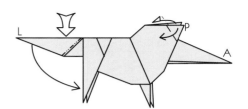

54 Reverse-fold point L downward. Valley-fold corner P down and to the left; repeat behind.

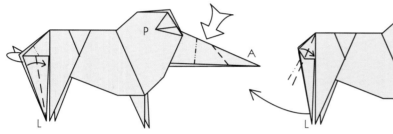

55 Narrow the tail (point L) with reverse folds. Reverse-fold the head (point A) twice.

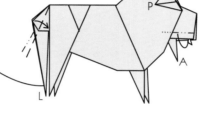

56 Wrap the top edges of the tail to the right and reverse-fold the rest of the tail to the left. Narrow the head with mountain folds.

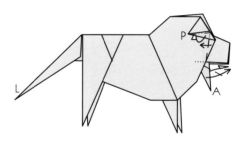

57 Fold the lower edge of point P (the ear) underneath. Outside reverse-fold point A (the jaw).

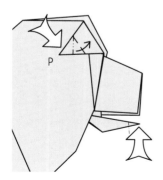

58 Squash-fold the ear. Repeat behind. Reverse-fold the tip of the lower jaw.

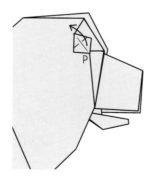

59 Petal-fold the ear. Repeat behind.

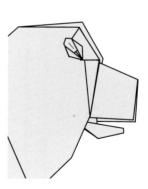

60 Finished ear.

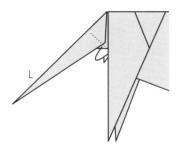

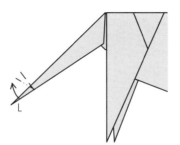

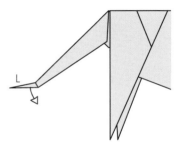

61 Mountain-fold the triangular flap inside the base of the tail. Repeat behind.

62 Crimp the tip of the tail.

63 Pull out some loose paper from the tip of the tail.

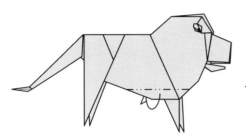

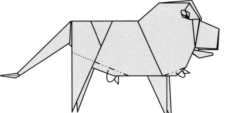

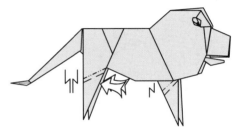

64 Mountain-fold the chest underneath. Repeat behind.

65 Mountain-fold the belly and the base of the mane. Repeat behind.

66 Crimp the hind legs. Pleat the forelegs.

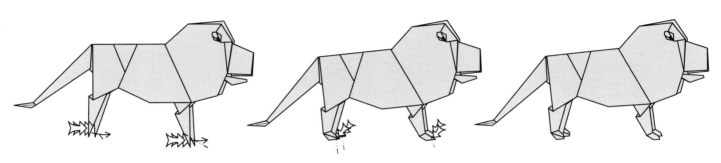

67 Squash-fold the feet.

68 Blunt the feet with reverse folds.

Finished Lion.

◆ gazelle ◆

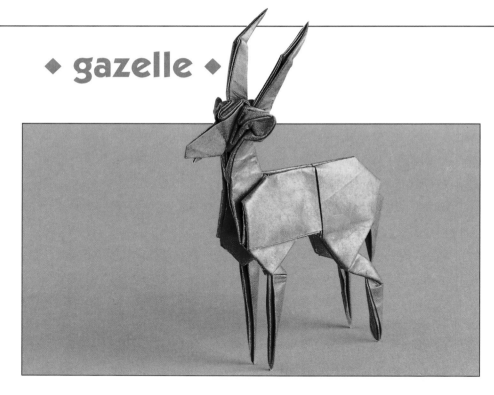

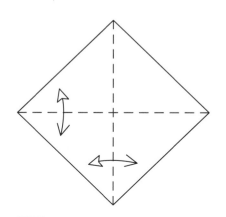

1 Begin with the white side up. Fold and unfold.

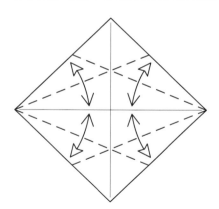

2 Crease the angle bisectors.

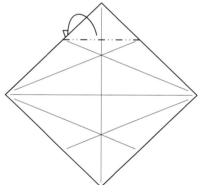

3 Mountain-fold the point behind.

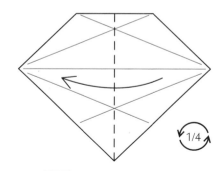

4 Fold the model in half and rotate 1/4 turn counterclockwise.

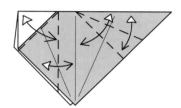

5 Fold and unfold.

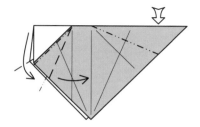

6 Crimp the left side downward. Reverse-fold the right point on existing creases.

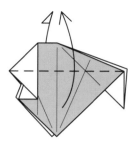

7 Fold the paper upward in front and behind.

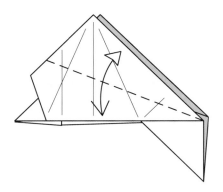

8 Fold and unfold. Repeat behind.

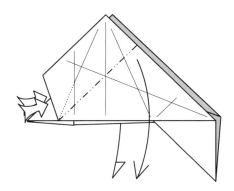

9 Squash-fold the edges. The long mountain folds run parallel to the raw edges.

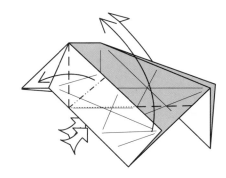

10 Squash-fold the edges upward.

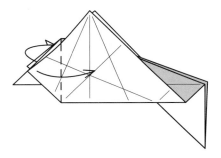

11 Fold one flap to the right in front and behind.

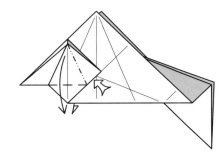

12 Petal-fold. Repeat behind.

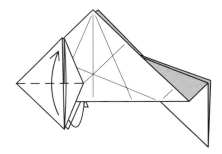

13 Fold the flap back up. Repeat behind.

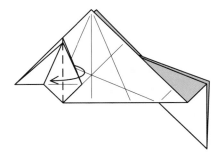

14 Fold one flap to the left. Repeat behind.

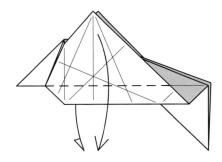

15 Fold down one layer. Repeat behind.

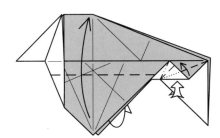

16 Fold the point up to the top edge. Reverse-fold the edge at the right. Repeat behind.

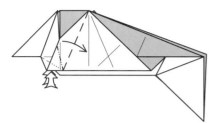

17 Squash-fold. Repeat behind.

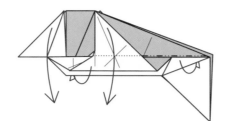

18 Swing two flaps down in front and tuck the narrow white edge up inside the model. Repeat behind.

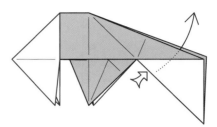

19 Undo the reverse fold.

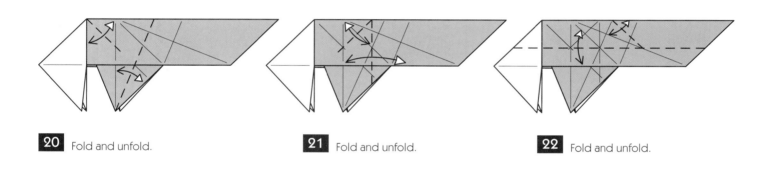

20 Fold and unfold.

21 Fold and unfold.

22 Fold and unfold.

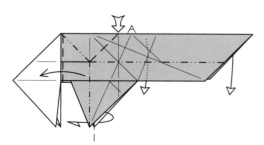

23 Crimp the right part of the model over to the left as you invert the top edge. Note where point A lands in the next step.

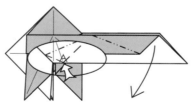

24 Crimp model internally and shift the right point downward.

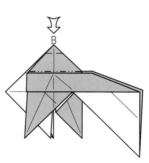

25 Closed-sink the triangular region (which makes a pyramid). Note the position of point B in the next step.

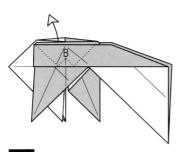

26 Pull out the white flap.

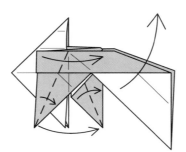

27 Fold one flap over and swing the right point upward.

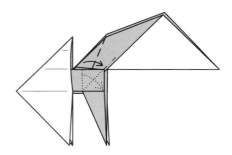

28 Reverse-fold the edge as far as possible to the right. Repeat behind.

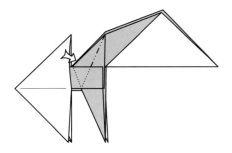

29 Sink the edge.

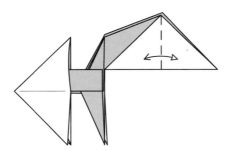

30 Fold and unfold.

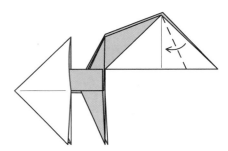

31 Fold the edge down to the crease.

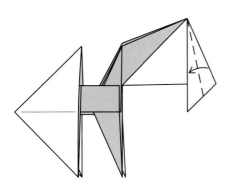

32 Fold the edge over.

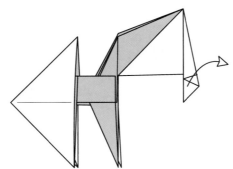

33 Unfold.

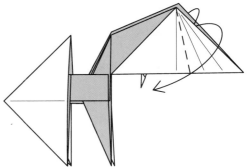

34 Outside reverse-fold on existing creases.

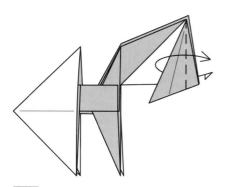

35 Outside reverse-fold again on existing creases.

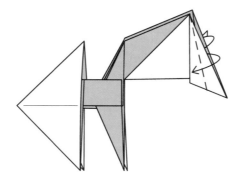

36 Outside reverse-fold one last time.

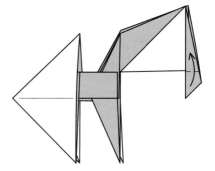

37 Fold the tip up.

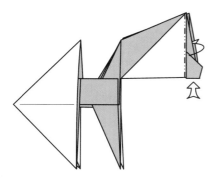

38 Reverse-fold.

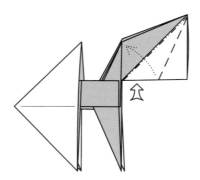

39 Reverse-fold back and forth.

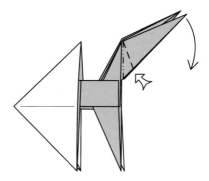

40 Spread the three points, two to one side, one to the other, and reverse-fold in and out. The base of the middle point will be locked to one of the other two points.

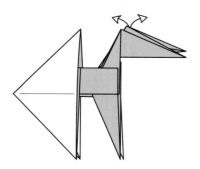

41 Rearrange the layers at the top so that the three flaps are separated; you will have to turn some valley folds into mountain folds and vice-versa.

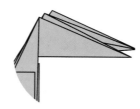

42 This is a close-up view of the result.

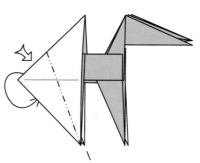

43 Reverse-fold the left side.

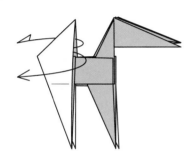

44 Unwrap the white flap.

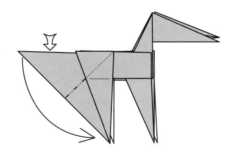

45 Reverse-fold the point downward.

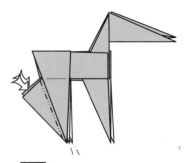

46 Reverse-fold both edges.

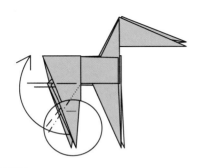

47 Crimp the tail (the middle point of three) upward as far as possible.

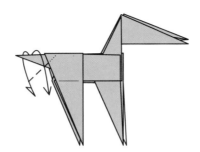

48 Outside reverse-fold the tail downward.

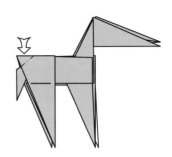

49 Reverse-fold the corner of the rump down inside the tail.

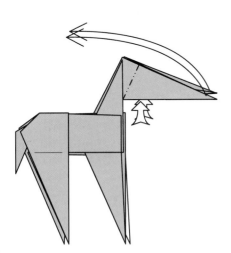

50 Reverse-fold the two points up to the left.

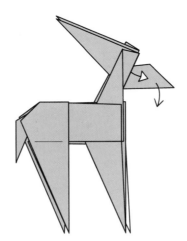

51 Pivot the head down.

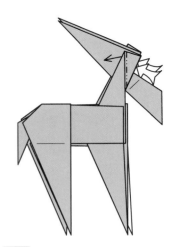

52 Reverse-fold the edge. Repeat behind.

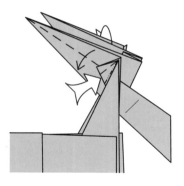

53 Valley-fold the long edge and simultaneously reverse-fold the corner near the head (you must do these together). Repeat behind.

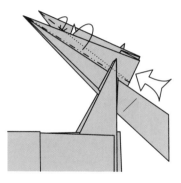

54 Fold the middle layer over to one side and reverse-fold the forehead to narrow the horns.

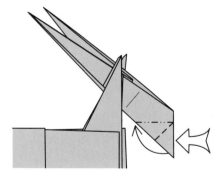

55 Reverse-fold the nose.

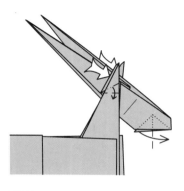

56 Valley-fold the point forward to make a jaw. Squash-fold the ear; repeat behind.

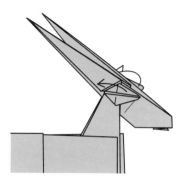

57 Valley-fold the ear backward. Repeat behind.

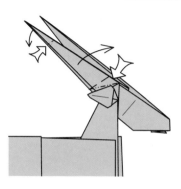

58 Crimp the horns in two places.

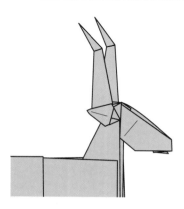

59 Like this. By varying the location and size of the crimps, you can get many different species of antelope and gazelle.

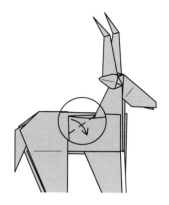

60 Valley-fold the hidden corner over to lock the back.

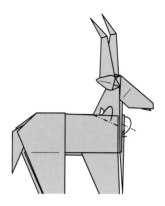

61 Mountain-fold the shoulder. Repeat behind.

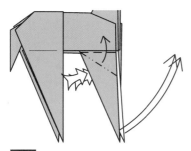

62 Squash-fold the forelegs.

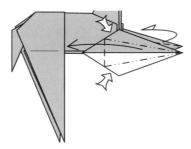

63 Petal-fold the forelegs.

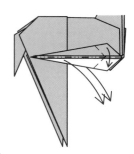

64 Close up and reverse-fold the legs downward.

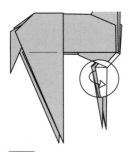

65 Tuck the white part of each leg inside the colored part; the far leg is shown in the cut-away view.

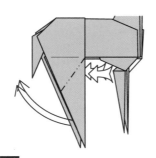

66 Reverse-fold the hind legs.

67 Narrow the legs with reverse folds.

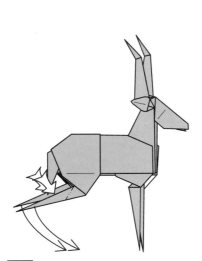

68 Reverse-fold the legs downward.

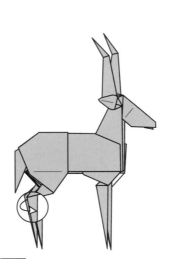

69 Tuck the inside flap of each leg into the outside flap. The far leg is shown here in cut-away view.

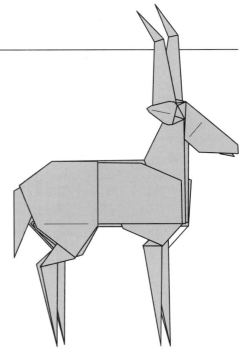

Finished Gazelle.

ACKNOWLEDGEMENTS

I am indebted to the many folders whose suggestions, recommendations, and comments have enriched my work over the years. For this collection, Jan Polish and the Board of Directors of the Friends of the Origami Center of America graciously permitted me access to their collections of unpublished models, several of which appear in this book with permission of the designers. Mark Kennedy additionally provided me with the names and addresses of many folders in one marathon long-distance telephone conversation (which he even paid for).

And of course, my deepest thanks go to those folders who contributed their designs to this work. I am especially pleased to include works from several promising young folders whose works have not appeared before in book form; the youngest, Aaron Einbond, is at this writing only 14 years old! All contributed models are credited to their designer; all uncredited designs are my own.

Sam Randlett, Akira Yoshizawa, David Shall, and Nick Robinson have offered many helpful suggestions on diagramming that I have incorporated into this book. A particular thank-you goes to John Montroll, my occasional co-author and publisher and constant friend; John introduced me to computer-aided diagramming, without which this book would not have been possible.

Diane Lang, Terence Hall, and Damian Thompson proofread the book; they filtered out many mistakes that might otherwise have made it into the final product. Needless to say, any mistakes that remain are entirely my own fault.

Lastly, I would like to offer a special thank-you to my wife, Diane, for her expert editing, advice, and patient testing of the models in this book.

SOURCES

There are many origami organizations worldwide that stock books, paper, and other origami supplies. Many of them also publish magazines that contain instructions for new and unpublished models. There are also often local or regional folding groups in the larger cities. For information on origami organizations and publications, you may write to the organizations listed below (please send a self-addressed envelope with two first-class stamps):

The Friends of the Origami Center of America
15 W. 77th St.
New York, NY 10024–5192
U.S.A.

British Origami Society
c/o Peter Ford
General Secretary
11 Yarningdale Road
King's Heath
Birmingham
B14 GLT
England

Nippon Origami Association
1-096 Domir Gobancho
12 Gobancho, Chiyoda-Ku
102 Tokyo
Japan